IMAGES
of America

HOMEWOOD

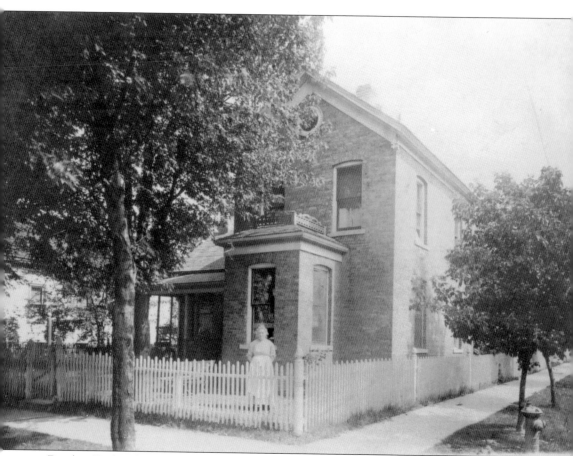

Dorthea Dorband stands in front of her home, which has been the headquarters and museum of the Homewood Historical Society since 1985. Built of brick produced at the Homewood brickyard, the home at 2035 W. 183rd Street is a designated Village of Homewood landmark. In later years, Charles and Hertha Howe lived there, and the building is commonly known as the Dorband-Howe house. (Courtesy of Homewood Historical Society.)

ON THE COVER: The Illinois Central Railroad (ICRR) built its depot in what became Homewood in 1853. The stop was originally known as Thornton Station for the village that already existed three miles to the east. With the arrival of the railroad, settlement around the depot began to grow and became known as Homewood in 1869. Here, rail workers and town children pose for a photograph at the depot in the 1890s. (Courtesy of Homewood Historical Society.)

IMAGES
of America

HOMEWOOD

James R. Wright

ARCADIA
PUBLISHING

Published by Arcadia Publishing
Charleston, South Carolina

Printed in the United States of America

Library of Congress Control Number: 2017937137

For all general information, please contact Arcadia Publishing:
Telephone 843-853-2070
Fax 843-853-0044
E-mail sales@arcadiapublishing.com
For customer service and orders:
Toll-Free 1-888-313-2665

Visit us on the Internet at www.arcadiapublishing.com

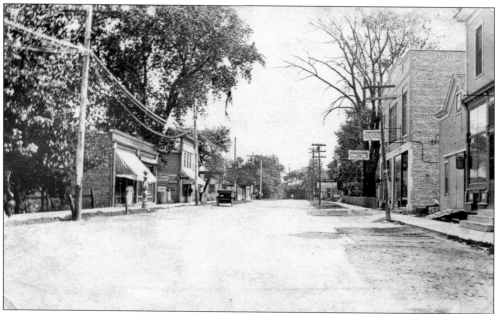

Main Street, now Ridge Road, is pictured looking east from Harwood Avenue in the second decade of the 20th century. The photograph shows how the street evolved into the principal business section of the village. A drugstore, barbershop, dry goods, and general store are visible. Cement sidewalks, as well as electric streetlights, have been installed, but the street remains to be paved. (Courtesy of Homewood Historical Society.)

CONTENTS

ACKNOWLEDGMENTS

Homewood is the culmination of a lifelong interest in Homewood history. Over the last three years, much time has been spent intensively researching and gathering photographs for the publication of this book. As is the case with any project of this magnitude, a successful end result could not have been accomplished without the help and advice of a great many people. Although it is impossible to mention everyone who has helped with this endeavor, the assistance of many deserves recognition.

First and foremost, appreciation is extended to the Homewood Historical Society and president Dixie Mitchell and the society's board of directors for allowing me access to their photographic collections and use of these photographs without reservation. Unless otherwise noted, the photographs presented in this book come from this collection. Many thanks are also extended to the generations of past and present Homewoodians, who have saved and donated their treasured and historical photographs to the society. Without their foresight and photographs, the society could not have built an archive of images that will be a treasure for this and future generations to come.

Many thanks are also extended to Karen Smith and Lynne Basler, who reviewed parts or all of the manuscript and offered their advice and counsel. I would like to also thank the staff at Arcadia Publishing for all their help and patience.

Finally, I would conclude by saying that while all attempts have been made to meticulously research the captions for this book, there are bound to be some errors and omissions. For these, I apologize and take complete responsibility. Historical research is a continuous process, and new information is uncovered all the time. Readers are encouraged to send their recollections, corrections, and photographs portraying Homewood scenes and personalities to the author in care of the Homewood Historical Society PO Box 1144, Homewood, Illinois 60430.

INTRODUCTION

Before the arrival of European settlers, what is now known as Illinois was occupied by tribes of Indians like the Iroquois, Sac (Sauk), Fox, Miami, and Potawatomi. In the Homewood area, the Potawatomi dominated and were in control at the end of the Revolutionary War, when settlers gradually began to move westward.

The Potawatomi were hostile to the settlers and sporadically attacked the scattered settlers throughout the region. The War of 1812 and the massacre that year at Fort Dearborn, located near the mouth of the Chicago River along Lake Michigan, continued to have a dampening effect on settlement in the area. It was not until after the end of the Black Hawk War in 1832 that the first wave of migration to northern Illinois from the northeastern and Mid-Atlantic states occurred. The migration was principally along the Erie Canal, completed in 1825, and east/west overland routes, like the Great Sauk Trail and from the south along the Hubbard's Trail, a route from Chicago to Vincennes, Indiana.

Earliest settlers in what was to become Homewood arrived in the 1830s and included David and Heman Crandall, Christopher Randall, Mehatabel Crary, Benjamin Butterfield, William Storm, William Young, and John and Job Campbell. Early sources place David Crandall in Illinois before 1832, the year he and his family had to retreat to the shelter of Fort Dearborn during the Black Hawk War.

The 1840s saw more families from the east move into the area, including those of Cyrus and Cornelius Eastwood, George Morris, David Hood, Horace Briggs, Samuel James, and James Hart. For years, it was believed that Hart and his family were the first settlers in Homewood, arriving sometime in 1834, but extensive research by Homewood historian Margaret Kuch debunked this long-held notion, with records proving the Hart family first appeared here in the late 1840s.

The late 1840s also saw the arrival of the first wave of German immigrants to Homewood. Liborius Hupe, Conrad Hecht, Samuel Riegel, and William Gottschalk and their families were the first of the Germans to arrive.

These are the names of many of the first settlers in Homewood. Most of the Germans stayed and built new lives for themselves and their families. Many of the "Yankees" moved west, selling their farms here, reaping profits, and buying more acreage in western states at lower prices.

The early settlers found the soil in Homewood to be fertile and well suited to farming. Homewood would essentially remain a farming community for the remainder of the 19th century and through the early years of the 20th century, but events that occurred in 1851 would set about changes that would affect the community forever.

On February 10, 1851, the Illinois State Legislature granted a charter for the Illinois Central Railroad Company. The railroad company built 705 miles of track that stretched from Cairo on the south to Galena on the northwest and included a branch to Chicago in the northeast portion of the state. Galena, a prosperous mining town, was considered the more important of the northern towns and the main line of the railroad was initially routed there. It was not long,

however, before the 366-mile stretch from Cairo to Chicago was bustling with traffic and became the true main line of the road.

As one of the main purposes of the Illinois Central Railroad was to "settle the prairies," the route selected to Chicago did not pass through a single settlement of more than 100 inhabitants and only passed near three of any importance at the time, one of these being Thornton, with about 150 inhabitants, which was three miles east of where the tracks in our area were finally laid.

When Illinois Central Railroad engineers surveyed this area in 1851, they reported only a few farmhouses visible from the point selected to establish the station. Since the depot was meant to serve Thornton, the thriving settlement to the east, the surveyors dubbed the spot Thornton Station. The name soon found its way onto railroad maps and would identify the stop for almost two decades.

The railroad's depot, completed in 1853, was built on the east side of the tracks, just south of what now is the intersection of Ridge Road and Harwood Avenue. The first passenger excursion train from Chicago to Kankakee stopped at what is now present-day Homewood on August 5, 1853.

The rail stop, like a highway interchange today, served as a magnet for development. In 1852, James Hart, seeing this potential, purchased the land that would become the central part of Homewood's future business district. This land was subdivided under the name Hartford in 1853. Hart later sold lots for business and residential use, and he wanted the settlement that was beginning to grow around the rail stop to be officially known as Hartford. Despite his wishes, the railroad won out, and the name Thornton Station endured until 1869 when Jabez Howe led a successful petition drive calling for the US post office to change the name of the settlement to Homewood.

Hart's speculation proved fruitful. Development soon followed. Henry Brinkman built a hotel and saloon on the north side of the Thornton Road east of the railroad right-of-way in 1852. The Thornton Road, an old Indian trail, later became Main Street and is now known as Ridge Road. Most of the early development took place on this street west of the Chicago-Vincennes Road (Dixie Highway).

In 1853, Charles Robinson, a prominent Blue Island merchant, built a general store with hotel rooms above it on the south side of the Thornton Road directly east of the rail depot. Also that year, another Robinson, Alfred (no relation to Charles), opened another general store on the north side of the Thornton Road east of the Brinkman Hotel.

The settlement continued to grow and, by 1855, had a population of 120 inhabitants. The Illinois Central annual report of 1855 described Homewood as a "small place but the land surrounding the station is well cultivated with large corn and wheat fields and at least 30 farm houses and farms are in sight of the depot." This was certainly quite different from the description given by surveyors four years earlier.

An increased population led to the establishment of a public school in 1855 and the first churches to serve the community. The First Presbyterian Church was organized in 1858, and the St. Paul Evangelical Lutheran Church, serving the German settlers, was founded in 1865.

Homewood continued to grow and prosper and officially incorporated as a village on February 14, 1893. Village government saw to improving life for residents. Wooden, later concrete, sidewalks and gas, later electric, lights were some of the first public improvements installed in town. A volunteer fire department was established in 1896 and a full-time policeman was hired to patrol the village in 1902. Telephone service came to town in 1901, electricity in 1902, and a waterworks was built in 1911.

Growth in the community led the Illinois Central Railroad to extend suburban train service to Homewood in 1890. This made the village a more attractive place to live for those who worked in the city. By the beginning of 1900, there were as many as 10 trains daily making the round trip to Chicago, some of which brought golfers to play at the country clubs in and near town. Some of the more affluent golfers built summer homes west of the railroad tracks adjacent to Ravisloe Country Club. Homewood's first bank opened in 1908, further adding to the town's appeal for those considering moving to Homewood. The village's population was 713 in 1910.

A renewed interest in building was fueled by the prosperity of the 1920s. Further improvements occurred. Streets stretched to the outskirts of the village, roads were paved, mains distributed water from municipal wells and a new sewer system was installed, which allowed the added convenience of indoor plumbing for homes within the village limits.

The Depression and war years saw slower growth and expansion in the village for more than a decade. Although spirits sagged somewhat, residents pulled together. One of the banks even remained solvent throughout these dark years, and village business leaders banded together and opened the Homewood Theatre in 1937, which provided a welcome diversion for townspeople. Homewood's population increased to 4,078 by 1940.

Post–World War II growth was explosive. New subdivisions sprouted overnight and shopping centers were built throughout the village to provide for the needs of the ever-increasing numbers of residents. Homewood's population soared to 5,887 in 1950, to 13,371 in 1960, to 18,871 in 1970 and to 19,724 in 1980.

Today, Homewood's population remains close to 20,000 residents and the village boasts a long-standing reputation of providing award-winning schools, an outstanding park district, and exceptional village services for its residents. The community offers a variety of shopping opportunities in the many retail centers in town and also hosts a number of annual events and festivals. All of this engenders a welcoming feeling that helps the village live up to its motto, "Home Sweet Homewood."

This volume chronicles the early years of Homewood's history through the 1940s. A future edition is planned that will explore the history of the village from the 1950s to the present.

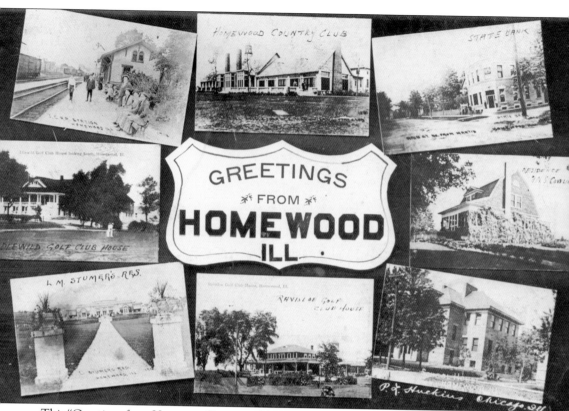

This "Greetings from Homewood" postcard from the 1910s illustrates a number of the landmarks important in the village at the time. These included the Homewood, Ravisloe and Idlewild Country Clubs, the Illinois Central Rail depot, the Homewood schoolhouse, the Homewood State Bank and several higher end homes built in the village at the time.

One

RURAL ROOTS

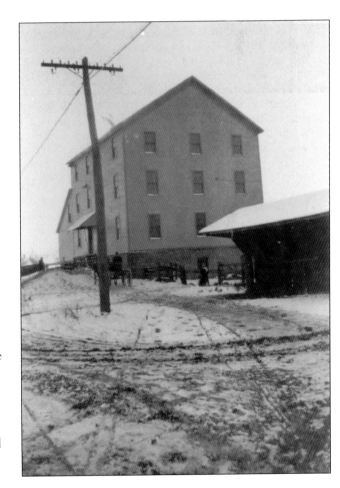

One of the earliest businesses in Homewood was a flourmill. Powered by steam instead of water or wind, the mill was patronized by farmers from miles around. Built in 1856, the mill was owned by a number of individuals through the years including George Morris, Nelson Seymour, and August Steiner. The foundation walls still stand and are incorporated as part of the building at 18216 Harwood Avenue.

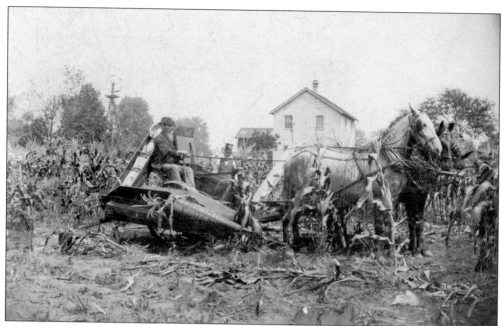

Homewood blacksmith and mill owner August Steiner was quite inventive. Steiner received patents on a cornhusker/harvester, one of the first successful mechanical harvesters. Representatives of the McCormick and Deering Reaper Works (later International Harvester Company) frequently came to Homewood to inspect the machine. Though they never purchased the patent rights from Steiner, it is likely they came away with ideas to improve their machines.

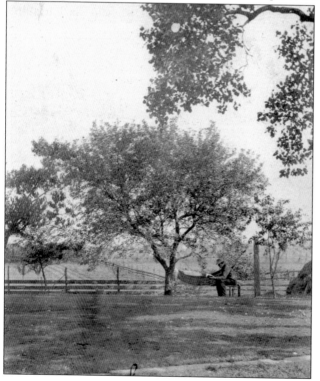

Charles Clark relaxes while reading a book in his yard overlooking the family farm north of 183rd Street, east of Gottschalk Avenue. Charles, son of early Homewood residents James and Eliza Clark, was born on the farm in 1853. Clark was well known for his strawberry crops, much of which he sold locally. The Clark farm was subdivided in 1925.

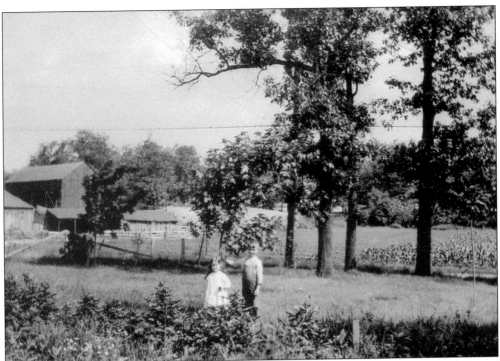

Mary and Don Mackenzie stand in the yard of the family farm located on Ridge Road west of Halsted Street. Heman Crandall homesteaded the acreage in 1838 and Samuel and Ann James purchased the property in 1848. Margaret Mackenzie inherited the farm in 1906, and Don, the last of the family to live on the property, moved away in 1980. The old farmhouse, built in 1916, still stands at 1055 Ridge Road.

Margaret, Don, and Mary Mackenzie pose on the family farm on the north side of Ridge Road, just west of Halsted Street. Beginning in 1918, a total of 1.5 million cubic yards of the sandy soil on the farm was used by the Illinois Central Railroad as fill to elevate its tracks above grade from north of Matteson to Chicago. Today, this part of the farm is now the Homewood Izaak Walton Preserve.

Sons Edward and Adolph Riegel sit beside their father, George, behind the family farmhouse. The Riegel farm was located on the east side of what is now Riegel Road between Willow Road and 187th Street. The Riegel family purchased the property in the mid-1850s, and George and his wife, Friedaricka, raised 10 children there.

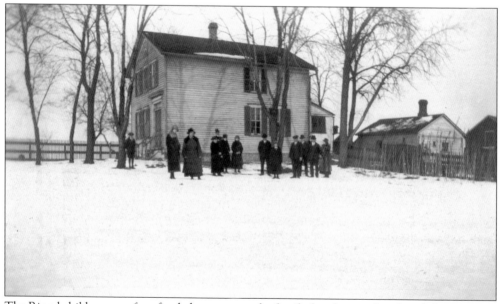

The Riegel children pose for a final photo next to the family farmhouse after their father George's death in 1926 at the age of 94. The farm was sold to developers for residential development, but the onset of the Depression delayed any home building on the property until the early 1960s.

14

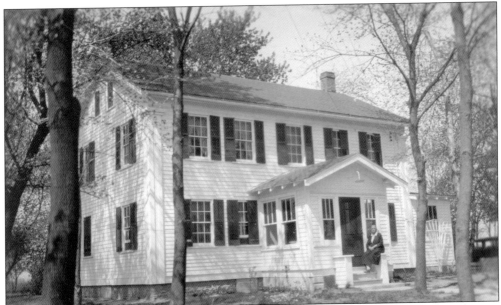

Louise Meyer relaxes on the stoop of her family farmhouse. The Meyers farmed land north of Holbrook and east of Riegel Roads. The house remained in the family until it and the large parcel it was located on was then sold and developed into the Meyer Cove subdivision in 2005. Descendant Mel Meyer was Homewood's police chief from 1951 to 1976.

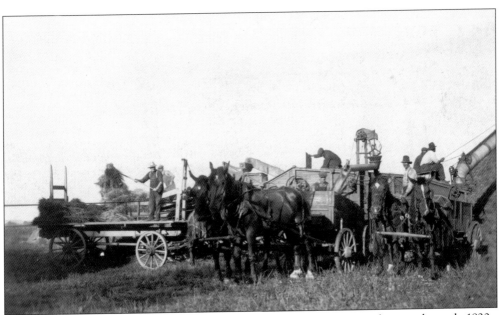

A steam engine and threshing crew works on the harvest at the Meyer farm in the early 1920s. Prior to the development of modern combine equipment, the harvest was labor intensive and required considerable mechanical, man, and horsepower to complete.

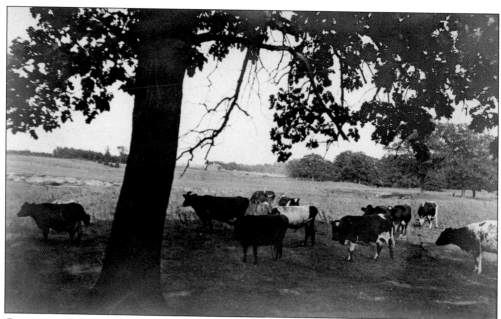

Grazing cattle was once a familiar sight around the Homewood area. This herd is pictured in a pasture on the Meyer farm along the banks of Butterfield Creek north of Holbrook Road. Most local farmers raised livestock to help supplement their incomes after their crops were harvested for the season.

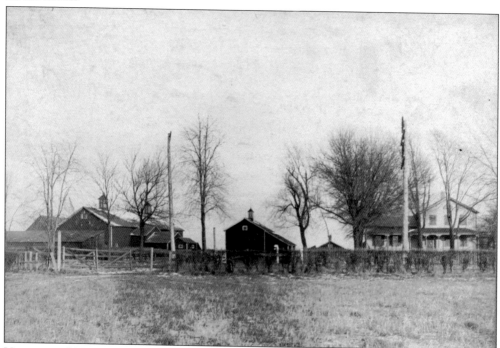

Herman and Maria Bramstadt homesteaded this farm, which was located on what became the Homewood-Flossmoor border on the east side of Kedzie Avenue, north of Homewood-Flossmoor High School. The Nietfeldt family farmed the property in later years, and Dora Nietfeldt was the last of the family to live in the house at 18659 Kedzie Avenue.

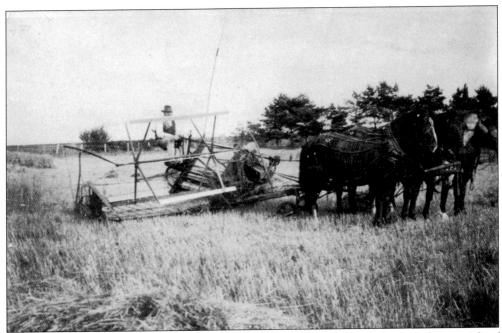

Henry Nietfeldt and his team are cutting and binding oats on the family farm on the east side of Kedzie Avenue north of what is now Homewood-Flossmoor High School. Land on the west side of town off Kedzie Avenue was some of last to be farmed in the village in the mid-to late 1970s.

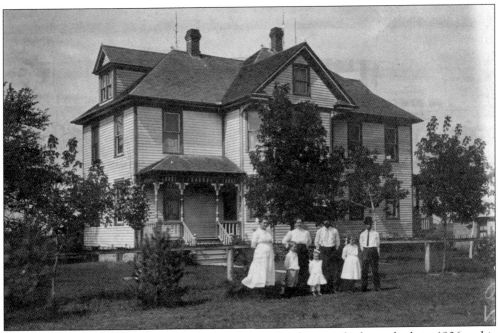

Henry Bramstadt and family pose in front of their farmhouse, which was built in 1906 and is still standing at 18445 Kedzie Avenue. From left to right are Amanda, Herbert, Caroline, Edna, Henry, Hulda Bramstadt, and Ottomar Hillger.

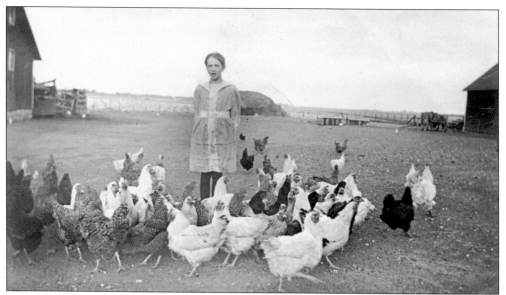

Farmwork was not only for adults. Children, like Edna Bramstadt, had a variety of chores to fulfill on the farm, including milking cows and feeding chickens. Most days, chores were done before and after school, no matter what the weather conditions.

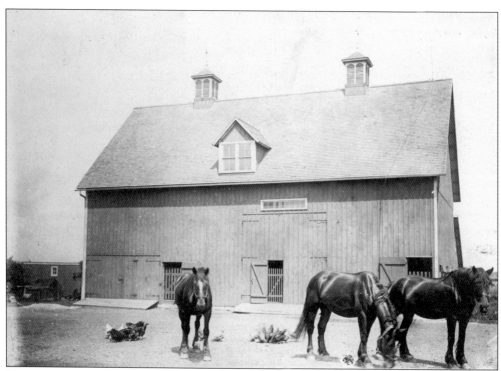

Horses were the main source of power on the farm even through the 1920s. They were well cared for and frequently were a part of the family. Henry Bramstadt's team included Pete, Frank, and Tom, pictured outside a barn on the farmstead on Kedzie Avenue.

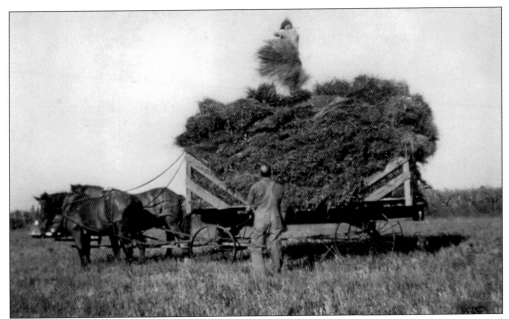

Harry Zeilenga watches as hay is loaded onto a wagon in a field on his farm. Zeilenga rented acreage on the south side of 183rd Street west of what is now Governors Highway. Harry, his wife, and their children lived in the large house that still stands on the southeast corner of Francisco Avenue and 183rd Street.

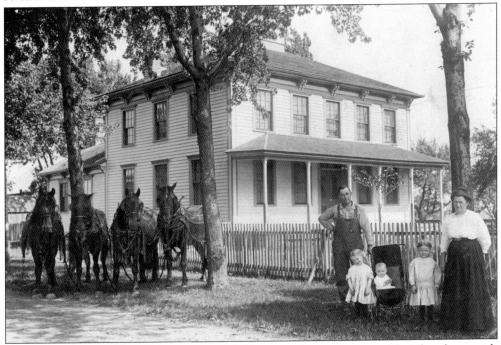

Fred Bramstadt, wife Wilhelmina, and their children proudly pose in front of their farm home with other valued members of their "family," their horses. The Bramstadt farm was located on Dixie Highway south of Terrace Road. The house remained for years. After it was torn down, Poppin' Fresh Pies, later Baker's Square, and now the Cottage Restaurant is located on the site.

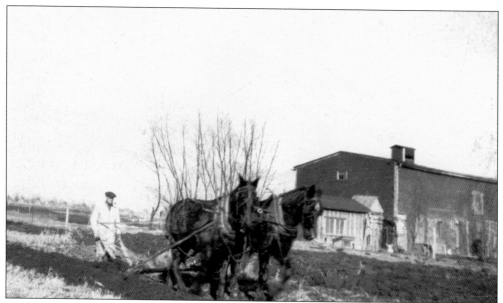

Ewald Puhrmann and his team of horses plow his farm fields preparing for spring planting. Puhrmann farmed ground on the north side of Ridge Road west of Ashland Avenue. The old farmhouse and barn survived until 1993, when they were burned down in a fire department training exercise. New houses were then constructed on the site just east of the Dairy Queen.

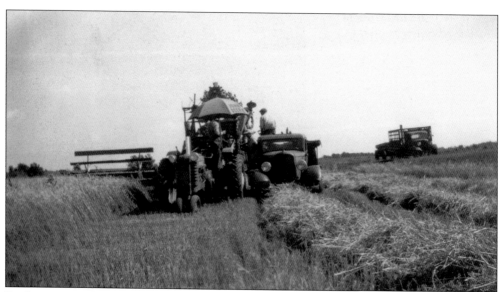

By the 1930s and 1940s, tractors and trucks were supplanting horses as the main motive power on the farm. Henry Leichering and his farmhands work harvesting the crops with a John Deere tractor, complete with an umbrella to shade the driver from the sun. Leichering lived on and farmed the old Riegel farmstead through the 1940s.

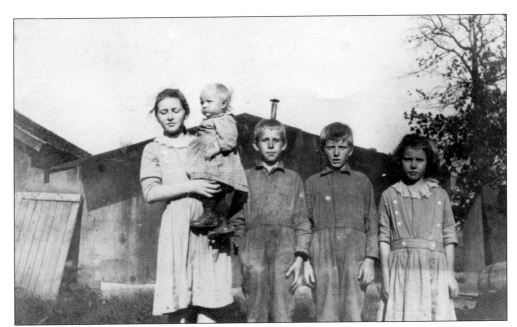

John and Gertie Langhout raised onion sets on a small farm on the east side of Halsted Street north of Ridge Road in the "teens" and early 1920s. The couple's children, Bertha, John, Clarence, Ellen, and Adele, were a big help with chores on the farm. Later, the family moved into town, where John worked as a carpenter.

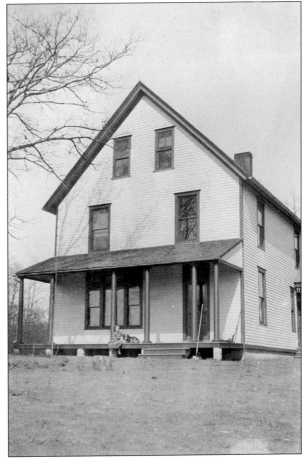

Little Grace Jaynes sits on the porch of the family farmhouse. The Jaynes' Oak Grove Farm was a well-known landmark on the east side of Halsted Street just south of what is now 175th Street. Alfred Jaynes operated a school for harness trotters, a horse race course, and stables here until his death in 1916. Later, a dog racetrack was located on the property where Menards stands today.

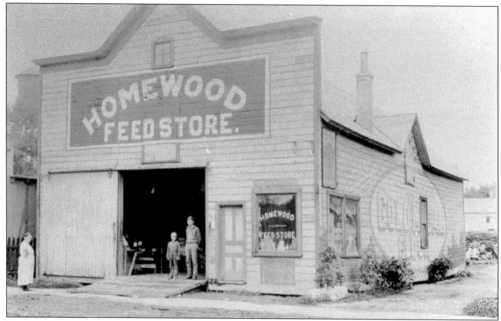

Businesses catering to farmers were important to the Homewood economy. The Homewood Feed Store sold feed, seed, and other farm supplies. Owned by Henry Fiebig, it was located on the east side of Harwood Avenue north of Ridge Road until the building burned down in 1928. Today, Camms Automotive is located on the site. Sophie Fiebig is pictured at left.

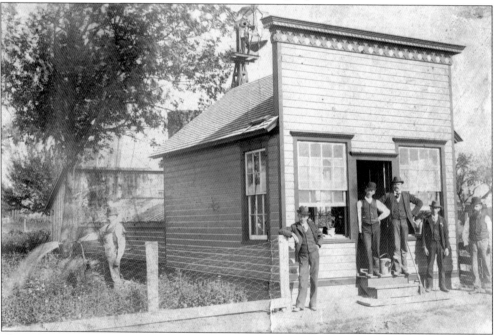

Florist Louis Schoof, at left, watering, grew flowers for wholesale shipment to flower shops in Chicago in his greenhouse and on a plot located on the northwest corner of Maria (183rd) Street and Morris Avenue after the turn of the 20th century. In his free time, Schoof was a correspondent for a local weekly paper, writing a column of Homewood news.

The Homewood Stock Farm, owned by the Metz family, was located south of 183rd Street and east of Western Avenue. Walt's Food Store currently occupies part of the site. The stock farm, established in Homewood in 1901, imported and bred Percheron, Belgian, and Shire draft horses for sale to farmers and teamsters throughout the Midwest.

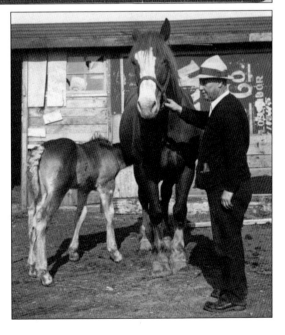

Louis Metz, owner of the Homewood Stock Farm, tends to a Belgian mare and foal on his farm. Metz developed a fine reputation and his horses were always in demand. His business prospered up until his untimely death in 1938 after he was kicked by a team of mules, a breed he began to raise in his later years.

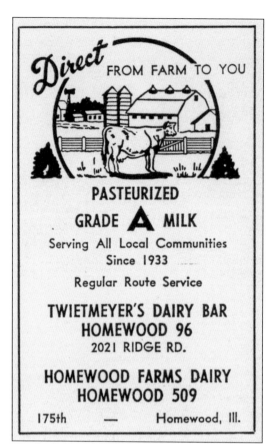

Direct FROM FARM TO YOU

PASTEURIZED

GRADE **A** MILK

Serving All Local Communities
Since 1933

Regular Route Service

TWIETMEYER'S DAIRY BAR
HOMEWOOD 96
2021 RIDGE RD.

HOMEWOOD FARMS DAIRY
HOMEWOOD 509

175th — Homewood, Ill.

Today, mega-farms supply much of the nation's milk, but that was not always the case. Local dairies, like the Homewood Farms Dairy owned by Fred Twietmeyer, processed raw milk from area farms and delivered the end product directly to the customer's home. Homewood Farms Dairy operations were located on 175th Street, west of Calumet Country Club.

Fred Twietmeyer's brother Henry, third from right, sold Homewood Farms Dairy milk products and quality ice cream at Twietmeyer's Dairy Bar, a popular spot for Homewood youngsters and adults alike, located at 2021 Ridge Road. After Henry's untimely death, his wife, Rosalie, ran the store through the mid-1950s.

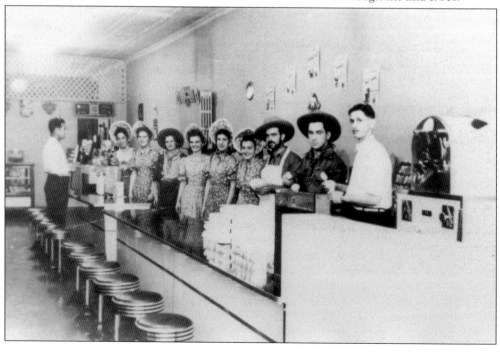

Grass was another agricultural product raised in Homewood. The Illinois Grass Company, which owned acreage east of Riegel Road and south of 183rd Street, sold sod to customers such as golf courses and country clubs throughout the Midwest. Their sod was even used at Wrigley Field and Comiskey Park. The business operated in Homewood from 1925 to 1941, when it moved west to acreage off Crawford Avenue. (Courtesy of Michigan State University.)

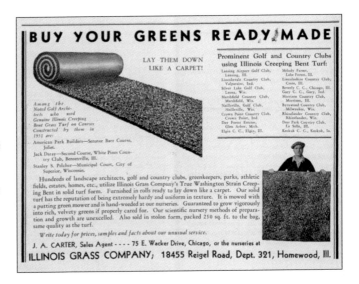

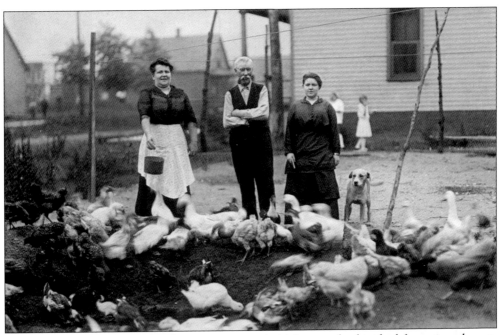

Even into the 1920s, some families in town raised chickens and other fowl for eggs and meat. The Dunlop family lived on Linden Road, east of Ashland Avenue, and raised quite a brood, as this photograph suggests. In later years, village ordinances prohibited raising farm animals like chickens in the city limits, until the village board approved an ordinance in 2014 once again allowing residents to raise chickens in town.

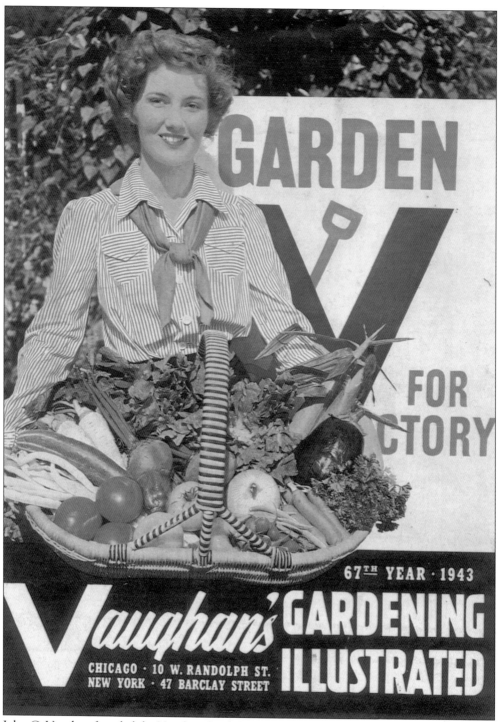

John C. Vaughan founded the Vaughan Seed Company in 1874 in Chicago. The Vaughan family owned a 140-acre farm that extended north of 175th Street and abutted the western border of Calumet Country Club. For years, the farm was used to raise gladiolas and elm, poplar, cherry, and apple trees for sale in the family business.

Two

RIDIN' THE RAILS

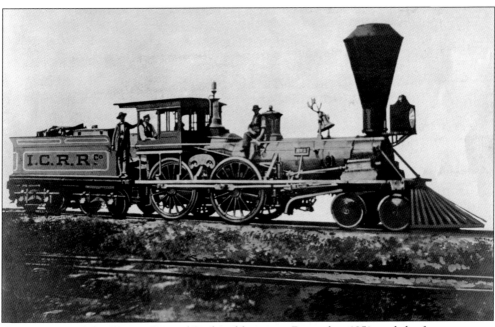

Construction of the Illinois Central Railroad began in December 1851, and the first passenger excursion train from Chicago to Kankakee, which stopped at what is now present-day Homewood, took place on August 5, 1853. The train was likely powered by this steam locomotive, Illinois Central engine No. 1.

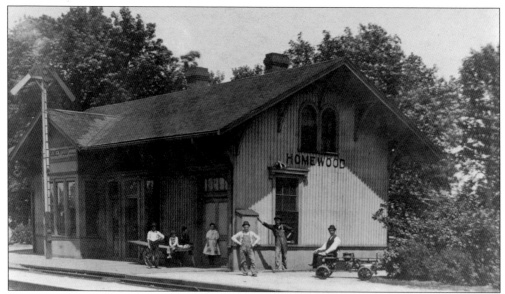

Railroad surveyors originally named the Homewood stop on the Illinois Central Thornton Station. The railroad's goal was to open the prairies to settlement and Homewood, like many towns the railroad would later serve, did not exist when the tracks were first laid. In 1853, the closest town to the Homewood stop was the thriving village of Thornton, about three miles away.

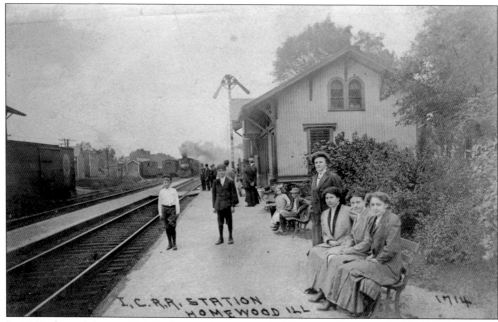

In 1869, the rail depot officially became known as the Homewood station. Built in 1853, it was a utilitarian, one-and-a-half-story wood-frame building that included living quarters on the second floor for the station agent and his family. The depot was the hub of the community and was located on the east side of the tracks, south of what is now Ridge Road.

James Cowing was Homewood's station agent from 1890 to 1907 and was responsible for receiving and dispatching all the mail and telegraph messages for the village. His wife, Nellie, was Homewood's postmistress from 1899 until 1925. Early in the 20th century, the Cowings were also involved in the operation of Homewood's telephone exchange, and many said no message was sent from or to town without one of the Cowings handling it.

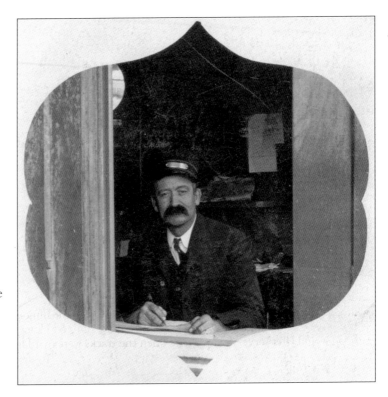

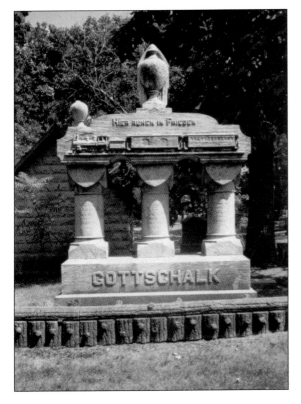

This unusual monument commemorates the deaths of Anna Gottschalk, her two-year-old daughter Lillian, and her sister-in-law Maria Gottschalk Witt, who were struck and killed by a train on the railroad tracks in Homewood on December 11, 1891. It is believed they were walking on the rails to avoid muddy roads. The monument is located in Homewood Memorial Gardens cemetery on Ridge Road, east of Halsted Street.

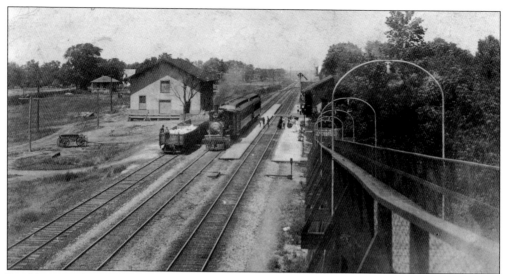

In addition to the passenger depot (right), the Illinois Central constructed a large freight warehouse in Homewood (left) to handle and store goods shipped into and out of the village. For many years, the freight depot was located on the west side of the tracks, across from the passenger station. This photograph looking north shows a "suburban" train providing service from Chicago arriving in Homewood.

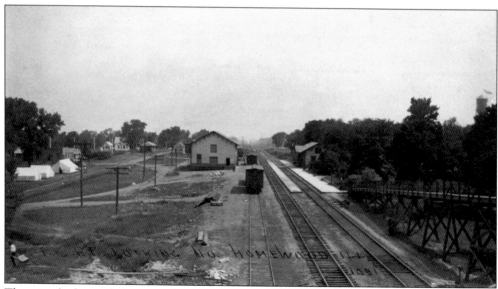

This view looks north from a pedestrian overpass, visible at far right, which the Illinois Central constructed in 1902 to allow members of the Ravisloe Country Club to safely cross the rails as they walked from the station to their clubhouse, west of the tracks. Also pictured are the freight and passenger depots and the relatively undeveloped nature of the area west of tracks near the country club.

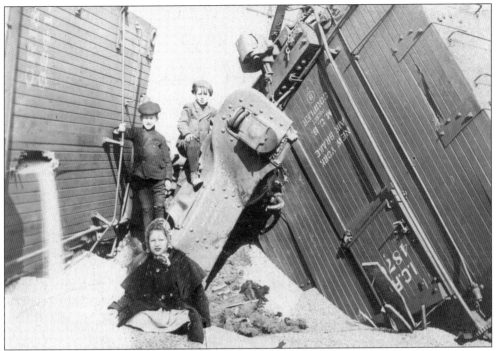

Accidents and derailments were common during the early days of railroading in Homewood. Here, Shirley Cowing (left), Emil Duwe (right), and his sister Augusta (front) play near overturned boxcars and on grain that continues to spill from one of the cars involved in this 1907 derailment.

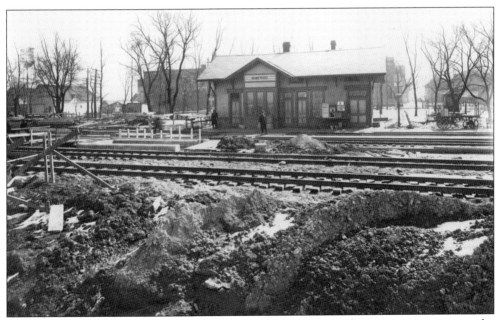

In 1911–1912, the Illinois Central started construction on significant improvements at the Homewood depot. Chief among them were the completion of a pedestrian underpass and longer and covered passenger platforms. Work on these improvements is visible in this photograph, which looks east and depicts some of downtown Homewood in the background.

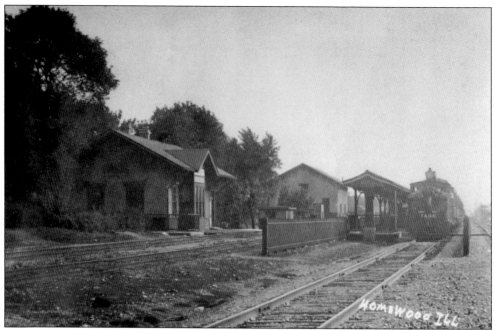

A northbound "suburban" train arrives at the Homewood station in this photograph, which illustrates the new passenger platforms and canopies constructed in 1912. Although not visible, the pedestrian underpass was another improvement completed at that time, as was the safety fencing, which prohibited passengers from walking across the tracks. By this time, the railroad's freight depot had also been moved to the east side of the tracks.

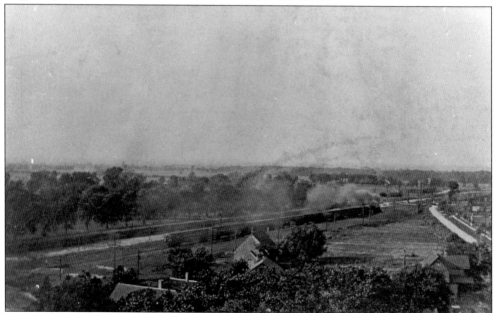

This aerial view shows an Illinois Central passenger train traveling north out of Homewood about 1915. Prior to construction of the north viaduct, the original route of the Dixie Highway is visible at right. When first paved, the highway crossed the rail tracks at grade around Maple Avenue, which ultimately proved deadly for many a motorist.

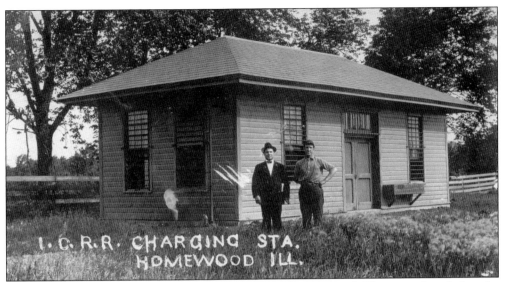

The railroad had many buildings for their operations in Homewood. This one, identified as the ICRR charging station in an early postcard, was used by the railroad's signal department as a machine shop, which used batteries as backup to regular line voltage as well as in remote areas where electricity was not available to power track circuits and signals.

Death's Angle was the name given the grade crossing of the Dixie Highway at the Illinois Central tracks. The name was very apt, as the crossing was dangerous and the scene of many accidents between trains and autos, some even involving fatalities. Here, the crossing is barely visible at right. North of the crossing, the Dixie Highway traveled on the west side of the tracks, as it does today.

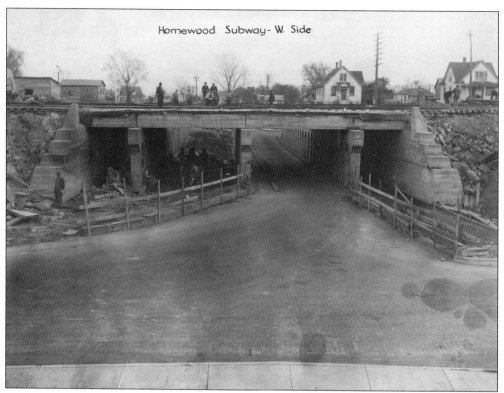

Homewood Subway- W. Side

To provide for better safety and separation of train and auto traffic, the Illinois Central completed construction of the Dixie Highway viaduct in the fall of 1922. Remarkably, over 90 years later, the viaduct looks much the same as when it was built except for the fact that concrete has replaced the original brick pavement.

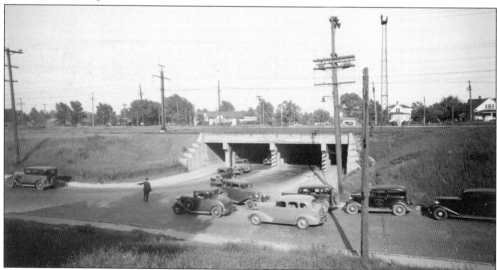

Traffic tie-ups have always been a problem on the west side of the Dixie Highway viaduct. In this view from the mid-1930s, Homewood's police chief, Walter Gleason, tries to bring some order at this three-way intersection. For many years, a Homewood policeman was stationed on the west side of the viaduct during the evening rush hour to help homebound motorists.

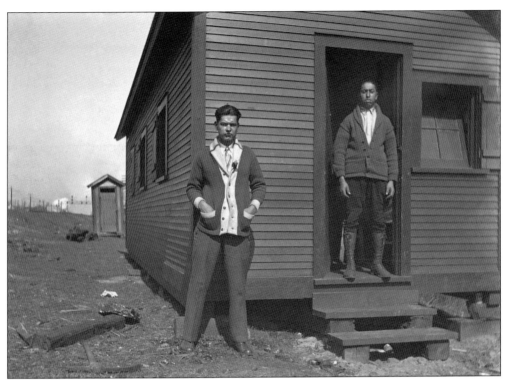

Railroading was labor intensive and before trains were switched electrically or pneumatically, switches were thrown manually. Switchmen were needed day and night, and they frequently were quartered in shacks adjacent to the rail tracks. This shack, complete with outhouse in the rear, was located on the east side of the Illinois Central tracks, just north of 183rd Street.

Life in a switchman's shack was a Spartan one—hot in the summer, cold in the winter, and crowded. Private times were rare, but this picture shows a quiet time for a switchman dressed in his best clothes in the Homewood shanty. With the exception of a few bed frames and some calendars decorating the walls, there were few comforts for the railroaders.

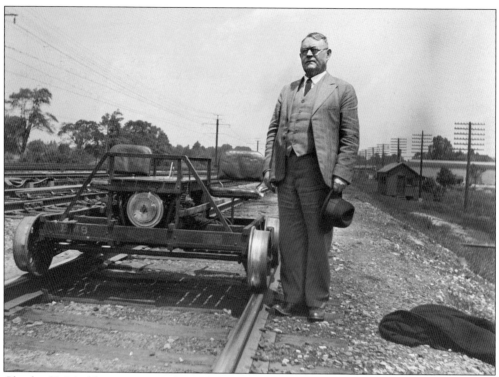

Charles H. Markham was president of the Illinois Central Railroad from 1911 to 1926 and was responsible for improvements that affected Homewood and the surrounding area. These included the construction of the ICRR's repair shops and rail classification yards north of town, the electrification of suburban rail service, and the elimination of all grade crossings between Homewood and Chicago. Markham is shown inspecting track south of downtown Homewood in the early 1920s.

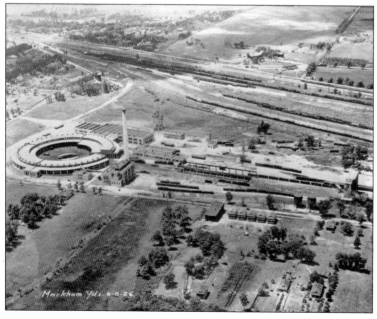

This aerial view from 1926 shows how the railroad has been a dominant force in Homewood's history. To the left, the Illinois Central's newly completed roundhouse and repair facility is visible, while to the right, the beginnings of the railroad's classification facility, named the Markham Yards in honor of the company's president, is shown.

To handle the ever-increasing rail traffic traveling through Homewood and the Markham Yards, the Illinois Central constructed a modern switching tower on the west side of the tracks just north of 183rd Street in 1924. The building still stands and is now used by Metra for its track control equipment.

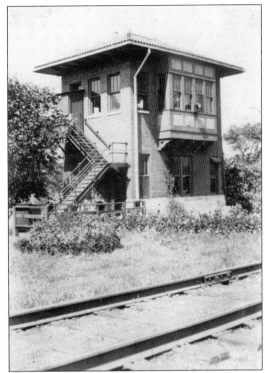

An interior view of the Homewood switching tower shows employees taking time out to pose near switching control levers. Rather than relying on switchmen to manually move switches trackside, the tower crew could simply move levers in their control room, which would mechanically move switches on the tracks. A map showing the location of the switches controlled by the tower was posted above the levers.

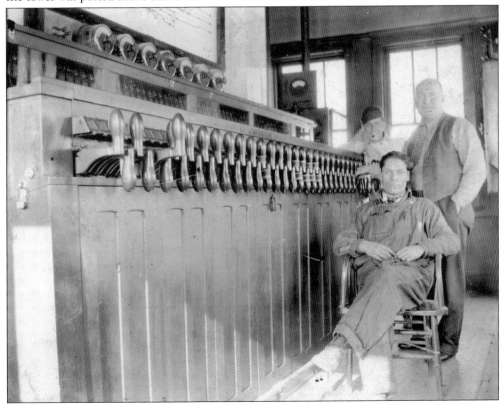

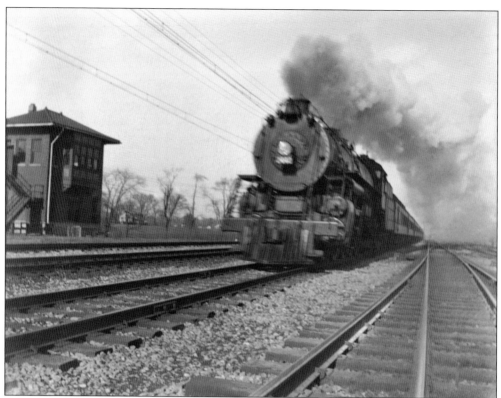

A southbound steam passenger train barrels through Homewood and past the Illinois Central's switching tower. Ravisloe Country Club grounds are partially visible to the left of the tower in this interesting photograph from the early 1920s.

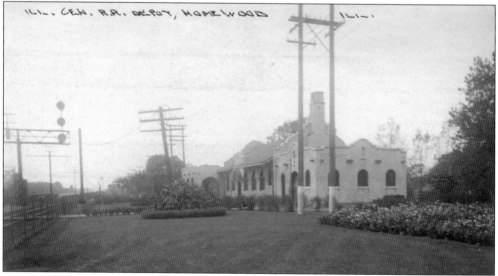

Homewood residents were thrilled by another major improvement completed by the Illinois Central in 1923: the construction of a new depot to replace the station constructed 70 years earlier. The new depot was built on the west side of the tracks in the Spanish Mission style, a design meant to mimic the nearby Ravisloe Country Club's clubhouse.

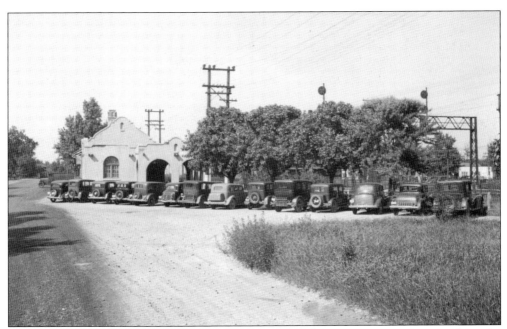

Commuter parking has always been an issue at Homewood's train station as this view from the mid-1930s suggests. Today, lots on both the east and west sides of the tracks provide parking for hundreds of commuters who travel daily by train to their jobs in downtown Chicago.

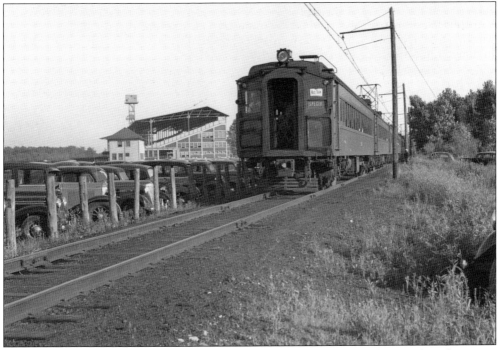

For decades, the Illinois Central offered race day special trains that provided service from downtown Chicago to Washington Park Race Track, located at 175th and Halsted Streets in Homewood. Race trains travelled along a spur from the main line that looped around the west side of the racetrack's grandstand building.

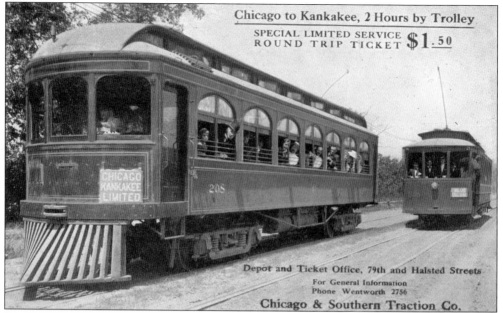

Chicago to Kankakee, 2 Hours by Trolley

SPECIAL LIMITED SERVICE
ROUND TRIP TICKET $1.50

Depot and Ticket Office, 79th and Halsted Streets

For General Information
Phone Wentworth 2756

Chicago & Southern Traction Co.

Homewood was served by the Chicago & Southern Traction Company (C&ST), an interurban trolley that provided service from Chicago to Kankakee from 1905 to 1927. In Homewood, C&ST tracks ran parallel to the west side of Halsted Street. Scheduled stops were located at Ridge Road, known as Franklin for nearby landowner Franklin Axtell, and at what is now 187th Street, which served passengers traveling to the Glenwood Manual Training School.

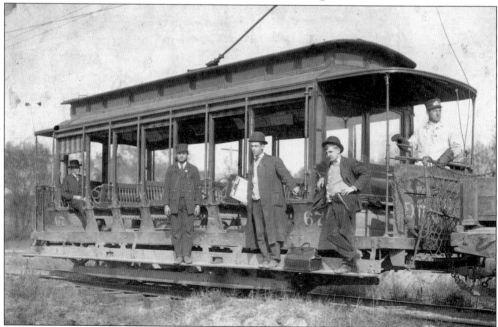

A C&ST car pauses near Ridge Road and Halsted Street, the Franklin stop. Henry Axtell, a neighboring resident, sits in the rear while another passenger standing on the running board at right is shown displaying a firearm in a holster on his belt. The C&ST was reorganized as the Chicago & Interurban Traction (C&IT) Company in 1911.

Three

READIN', 'RITIN', 'RITHMETIC

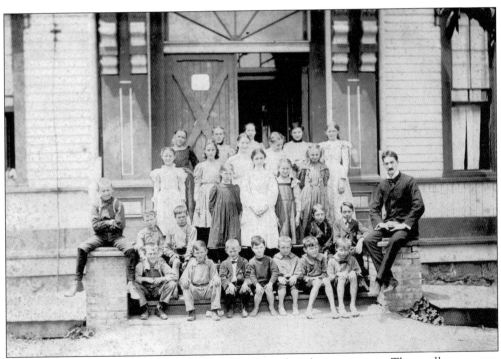

No photographs of the first public school in Homewood are known to exist. The small, one-room, wood-frame building painted red was constructed shortly after early Homewood settler James Hart deeded property to the School Trustees of Thornton Township, recorded on May 1, 1855. Likely the schoolhouse was completed before school started that fall. The building was located just east of the present-day intersection of Harwood Avenue and Pine Road. This view from 1896 or 1897 shows students in front of the second public school. Judging from some, shoes must have been optional. Clark R. Potter is the teacher.

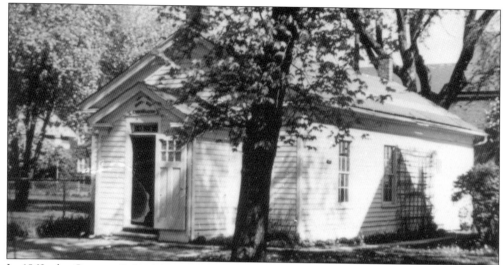

In 1862, the German School Society of Thornton Station (the first name for Homewood) was established by local German immigrants. Land was purchased west of the present-day intersection of Olive Road and Dixie Highway for $42 and this building, the first parochial school in Homewood, was built. Children were taught in the German language and not only learned the three Rs, but also a fourth: religion. After a dispute arose among the organizers, the school closed in 1864.

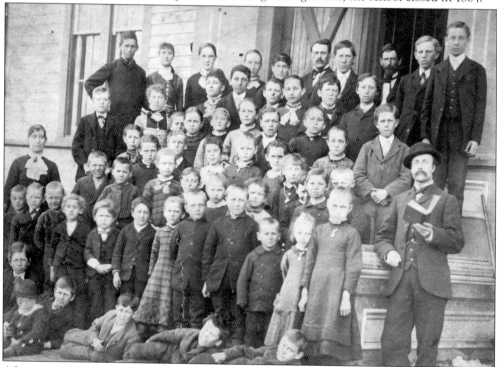

After years of overcrowding, a second public school was built to replace the original building. The new two-room schoolhouse was more centrally located and was built on the Chicago-Vincennes Road (Dixie Highway) just north of St. Paul Church. Independence Park occupies a part of this site today. The two rooms required two teachers, and the 1880 census identified Oscar Andrews and Peter Lennon as the teachers residing in Homewood.

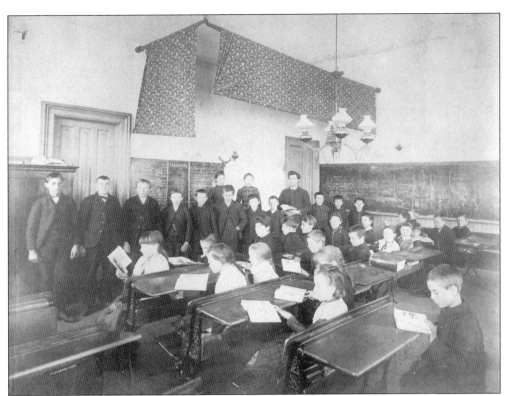

This interior view of Homewood's two-room schoolhouse shows it was relatively well appointed for the time with plastered walls, blackboards, kerosene chandelier, and double-seat desks for the children. Likely taken in the late 1880s or early 1890s, S.E. Merrill was the teacher at the time. The old two-room schoolhouse still stands, though significantly remodeled, at 18120 Dixie Highway.

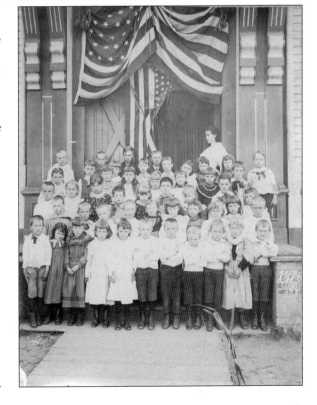

Maie Gleason, the sister of Homewood's first police officer and police chief, Walter Gleason, taught school for a number of years in Homewood. She poses here with a group of well-behaved children from the primary grades in this photograph from June 1895. Maie married Mowry Axtell, a Presbyterian minister, in July 1902 and moved from town, thus ending her tenure in the Homewood school.

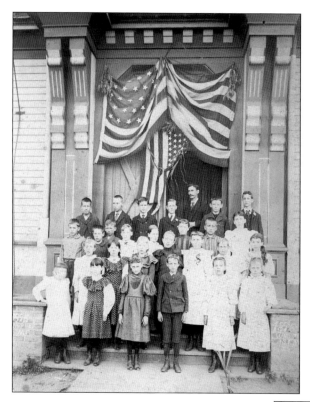

Sanford E. Merrill was listed in the Cook County school superintendent's biennial report as the second teacher in Homewood during the 1895 school year. This photograph was taken that June. Merrill taught the upper grades and taught in Homewood for a number of years. Teacher longevity was typically short at this time, and Merrill was listed as teaching in the South Holland school the following year.

HOMEWOOD PUBLIC SCHOOL,
Homewood, Illinois.

Monthly Report of School-work

of *Frank P. Cowing*

for the month of *Nov.* 190*2*

READING . .	9	DRAWING . . .	9
ARITHMETIC .	E.	DEPORTMENT .	
SPELLING . .	E.	DAYS OF SCHOOL	17
WRITING . .	9	DAYS PRESENT .	17
ENGLISH . .	9	DAYS ABSENT .	
GEOGRAPHY .	E.	TIMES TARDY .	
HISTORY . .	E.	APPLICATION .	9
PHYSIOLOGY .	E.	GEN. AVERAGE .	E.

The character of the work is indicated thus:— E—Excellent; G—Good; F—Fair; P—Poor.

Please sign your name in the proper space below and return to the teacher at your earliest convenience.

Yours truly,
Herman J Broek

I have examined the above report.
J. a Cowing

This "Monthly Report of School-work" from November 1902 shows the typical class work for a sixth grader. Reading, arithmetic, writing, spelling, geography, history, drawing, and physiology were subjects taught at the time. Students were also graded on "deportment" and "application." Student Frank P. Cowing would go on to gain a law degree and run a real estate office in Homewood. Herman J. Broek was the upper-grade teacher and school principal at the time.

By 1904, Homewood's two-room schoolhouse had again become overcrowded and a referendum for construction of a four-room school was approved that year. The old schoolhouse was sold to Billy Mueller, who moved it a lot to the north and remodeled it to convert into apartments. It was further altered in ensuing years and today stands at 18120 Dixie Highway, housing businesses on the first floor and apartments on the second floor.

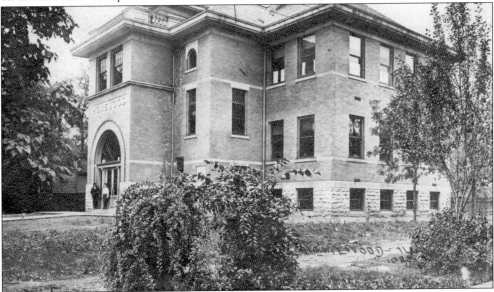

The referendum for a $10,000 bond issue for a new school building passed by a large majority. Construction of a two-story brick building, known as the Standard School, was completed during the summer of 1904. The building housed four large classrooms with plastered walls, wood wainscoting, hardwood floors, two center cloakrooms, an office, attic, and basement. The school opened that September with 117 pupils in eight grades. Standard School was used through 1970, when it was demolished.

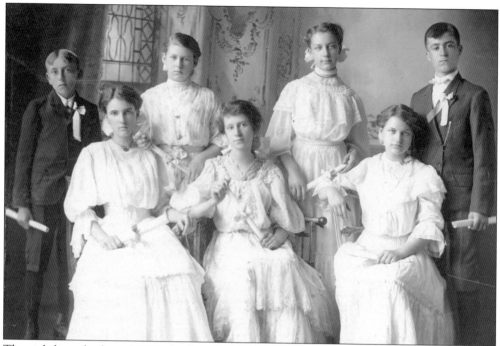

The eighth-grade class of 1905, the first to graduate from the Standard School, is shown in this photograph. Pictured from left to right are Fred Borgwardt, Eleanor Howe, Lulu Shutius, Marguerite Schellenbarger, Myrtle Harwood, Flossie Van Gunter, and Frank P. Cowing. Borgwardt would serve as Homewood's mayor from 1937 to 1945.

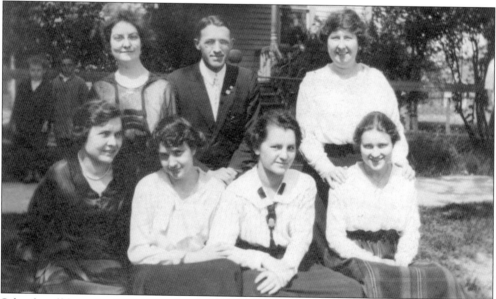

School staff from the 1917–1918 school year gather in front of the old Zimmer home, which was located on the southwest corner of Martin Avenue and Main Street (Ridge Road). James B. Coburn, second row center, was principal and his wife, second row left, taught, as did the other teachers, only identified as Miss Nickerson, Miss Silbermann, Miss Rinker, Miss Kennedy, and Miss O'Brien. The Zimmer home was used for classes to help ease overcrowding at Standard School.

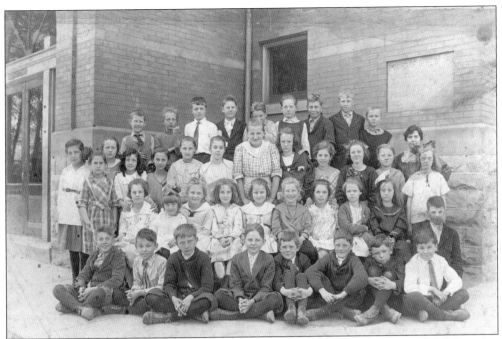

Kids have not changed much over the years; some were just as mischievous in 1921, when this photograph was taken, as some children are today. Other than a few "funny" faces and one boy appearing to pull a girl's hair, the mischief is innocent. One boy in the rear row (second from left) is letting everyone really know how he feels, and his feelings have been recorded for posterity.

By the early 1920s, Standard School was "bursting at the seams." To address this situation, the school board purchased four acres at Highland Avenue and Main Street (Ridge Road) and bonds were issued for the construction of a second school building. Named Central School, construction was completed in May 1923 with three classrooms, an office, and an auditorium. By 1928, eight classrooms, a gymnasium, and locker rooms were added to accommodate the ever-growing numbers of school-age children in town.

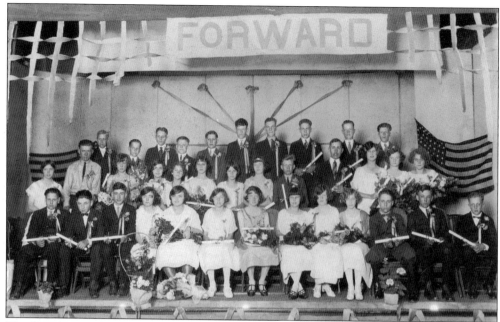

The first class graduated from Central School in 1923. Suits, dresses, flowers, boutonnières, and corsages were all part of the dress for the happy occasion. Thirty-six students graduated this year, which was a good indication of the growing enrollment Homewood schools would see throughout the Roaring Twenties.

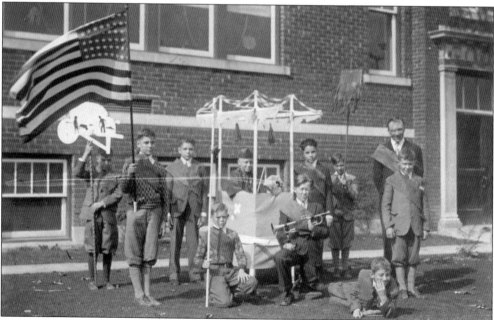

A group of boys prepare for a citizenship parade held on the grounds of Central School after the school opened in 1923. A number of boys pictured are wearing knickerbockers (also called knickers or "knee pants"), a pant style popular for younger boys in the early 20th century. Typically, boys graduated to long pants after grade school. School superintendent/principal Sylvances E. Adair looks on.

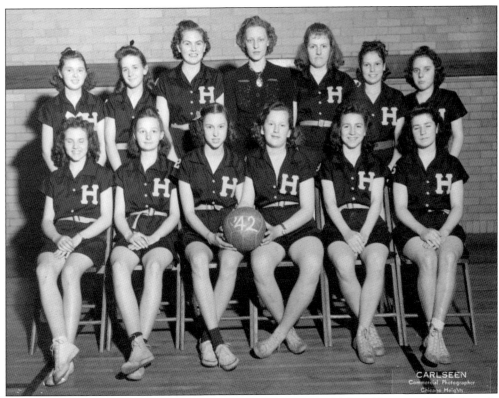

Sports, particularly basketball, were an important part of school life in Homewood and the girls participated with their own team, as this photograph from 1942 suggests. The team consisted of, from left to right (first row) Dolores Gardner, Lois Kruger, Virginia Tharp, Helen Gjerde, Jean Beesley, and Alice Neal; (second row) Shirley Day, Norma Apel, Marilyn Frank, Leta Toll (coach), Marion Bute, Bobbetty Anderson, and Betty Rahn.

The boys also were actively involved in sports and had their own basketball teams. This seventh- or eighth-grade team posed in the gym at Central School for their team picture in 1947. Unfortunately, the boys were not as good about recording their names on the photograph as the girls were.

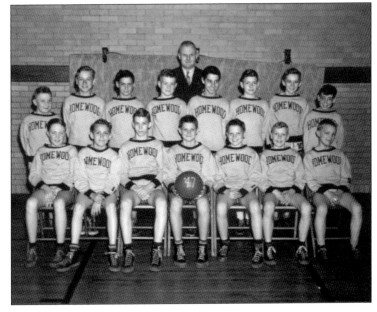

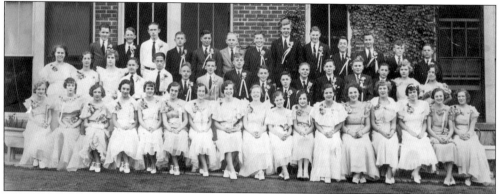

This 1934 graduation class photograph taken at Central School shows 46 students. The Depression years were tough ones for the residents of Homewood, as they were for the rest of the country. Homewood schools actually saw a decrease in population during the decade. In 1929, there were 429 students enrolled in Homewood schools, and this number dropped to about 350 in 1939.

PART I SCHOLARSHIP							PART II CITIZENSHIP						
	REPORT PERIOD					Yearly Aver-age		**REPORT PERIODS**					Yearly Aver-age
SUBJECTS	1st	2nd	3rd	4th	5th		SUBJECTS	1st	2nd	3rd	4th	5th	
Reading	B-	A-	A-	A	A	A	Courtesy	B	A	A	A	A	A
Spelling	B+	B	B+	B+	A	B	Cooperation with Teacher	B	A-	A	A-	A	A
Writing	B	B	B	B	B+	B+	Cooperation with Pupils	B	B	B+	B	B	B
Arithmetic	B-	C+	B-	B	B	B	Work Spirit	B	B+	B+	B	B+	B+
English	C	B	B	B	A-	A-	Neatness	B	B	B	B	B	B
Geography							Dependability	B	B+	A	A	A	A
History							Attentiveness	B	B+	A	A	A	A
Civics							Promptness	B	B+	A	A	A	A
Health Education													
Music	B+	B+	B+	B+	B+	B+							
Art	B	B	B	B	B	B							

PART III

Deportment	B+	B+	B+	B	B+	B+
Times Tardy	0	0	0	0	0	0
Half-Days Absent	0	0	24	0	0	2

Interest in Library Reading	B	B	B	B	B	

ACHIEVEMENT PROJECTS (Designate)

No. of books read to close of school_____

GRADE {	Superior 95 to 100 A	Good 85 to 95 B	Fair 75 to 85 C	Poor 70 to 75 D	Failing Below 70

CERTIFICATE OF PROMOTION

Promoted to ___Fourth___ Grade Date___June 3___ 19_38_

Total Number of Achievement Credits Earned to Date_____

Teacher _Marjorie Landis_

A third-grade report card from 1938 shows subjects similar to those taught at the turn of the 20th century. The school district offered health education, music, and art as additional courses. Students were not only graded on "deportment," but they also had a list of other characteristics they were judged on, including cooperation with the teacher and other pupils, courtesy, work spirit, dependability, and attentiveness.

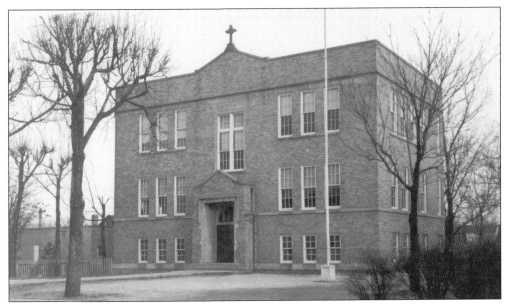

St. Joseph School was built in 1926 and opened on September 7, 1926. Seventy-two students were enrolled that year and were taught by three nuns from the Dominican Order of Adrian, Michigan. The school initially had six classrooms and a full basement with restrooms, a boiler room, and a room for church and school activities. Two of the classrooms on the upper floor were used as a residence for the sisters.

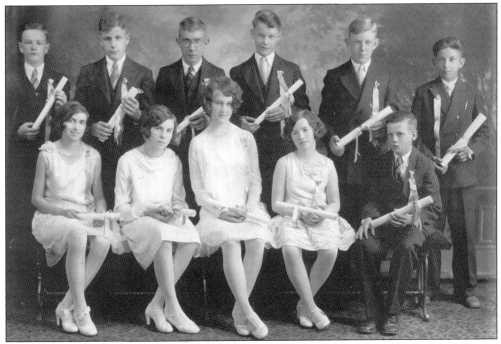

This graduation photograph of the St. Joseph School class of 1929 shows graduates sharply dressed and with diplomas in hand; from left to right are (first row) Helen Montbriand, Betty Palus, Ruth Lowell, Mary Mahoney, and Robert Doeseckle; (second row) George Bentley, Bill Lowell, James O'Brien, John Armand, Melvin Melia, and Reno Caldanaro.

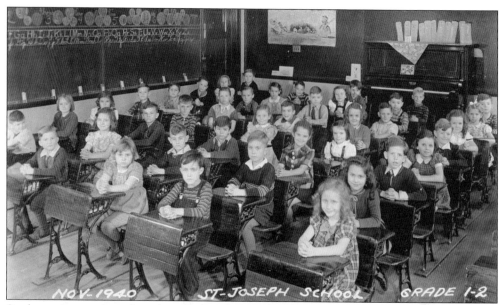

Students were taught in four classrooms at St. Joseph School; two grades shared a room and were taught by the same teacher. First and second graders shared this room in 1940, and 40 students are pictured. Handwriting and penmanship look to be an important part of the instruction, and the classroom even had a piano for instruction in music and song.

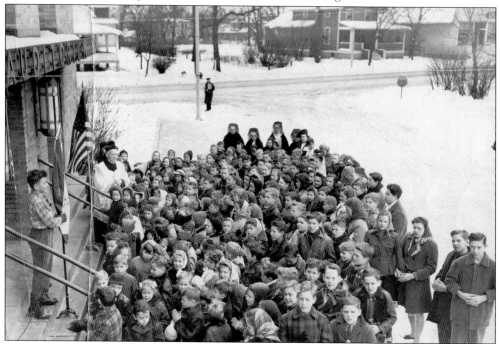

The village hall auditorium was well used by schoolchildren in Homewood, including those from St. Joseph School. In addition to basketball games, recitals and plays, graduations, and other large school and parish assemblies were held there. No doubt the close proximity between the parish and hall was welcome. Here, students assemble for a final prayer with Father Stephen Sullivan and school faculty during a wartime assembly.

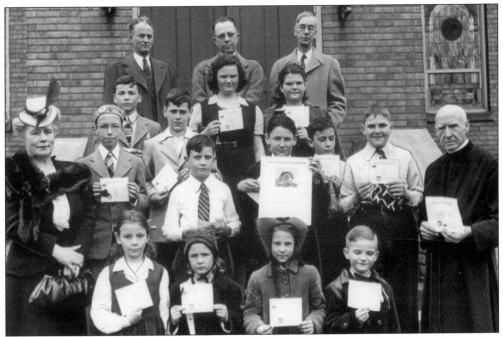

The US Treasury Department presented citations in April 1944 to St. Joseph School and individual students for their efforts raising funds for World War II bond and stamp drives. Children receiving awards were Rosemary Ohnemus, Virginia Paulson, Mary Alice Centers, James Stelter, James Swann, Eugene Masini, Freddie Turner, James Driscoll, Leroy Montbriand, Roy Peloquin, George Messenger, William Ohnemus, Judith McGuire, and Angela Mantell. Mrs. Leo Cummings (second row, far left) represented the treasury department. Also pictured in the back row are, from left to right, Vincent McGuire, Abbott Spaulding, William H. Cato (Homewood postmaster), and Father Stephen Sullivan (second row, far right).

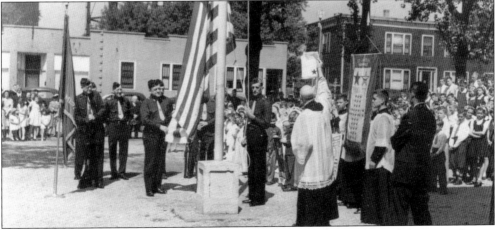

In recognition of St. Joseph School's fundraising for the war, the Homewood American Legion Post presented the school with an American flag to go along with the Minuteman flag presented by the US Treasury Department. Both flags were blessed and raised in a ceremony held May 26, 1944. Father Stephen Sullivan holds the Minuteman flag while legion members begin raising the US flag as students and parishioners look on. This view looks west across Dixie Highway to where the police and fire departments are today.

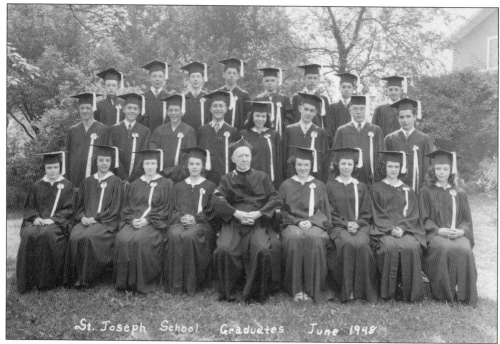

The St. Joseph School class of 1948 poses for this photograph. From left to right are (first row) Margaret Harrington, Virginia Wirtz, Mary Ann Ingalls, Caryl Chenot, Father Stephen Sullivan, Ruth Brock, Betty Wiege, Judith Gridley, and Rosemary Ohnemus; (second row) Jerome Panozzo, Paul Yahner, Larry Dagenais, John Sekosky, Patricia O'Hara, William Drolet, and Robert Triumph; (third row) John Regan, Richard Cullom, Thomas Kak, Robert Moore, Jack Luedtke, James Gschwend, Richard Grogan, and Bruce Rabernak.

Salem Lutheran School opened September 8, 1925. Originally, classes were held in the church. A new school building was built south of the church and was dedicated December 11, 1927. The school held two classrooms for all eight grades. This school building was used until 1965, when a new school was built on Ashland Avenue south of 183rd Street. The old school still stands at 18332 Morris Avenue and is now home to the Neighbor Masonic Lodge.

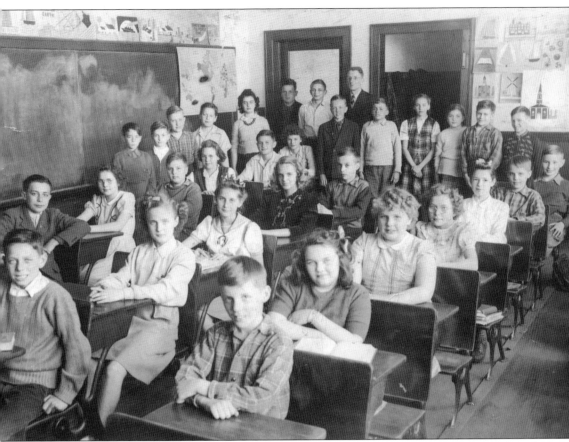

Students of the upper grades at Salem Lutheran pose in their classroom in 1944. In rows from front to back are (left row) Norman Kranz, Lois Meyer, Walter Goesel, Ruth Fedderson, Gerhardt Kaufmann, and Florence Lively; (center row) Helmuth Twietmeyer, Wilma Utermark, Georgeann Wies, Susan Ries, and Donald Walkenhauer; (right row) George Thies, Jane White, Phyllis Cochrane, Delores Meyer, Marion Kowalk, Richard Walkenhauer, and Heinz Kaufmann. Standing in the back, from left to right, are Christian Kranz, Richard Goesel, Richard Dykstra, Donald Killmer, Marilyn Killmer, Art Cochrane, Theodore Fieffer, teacher Theodore Ries, Leroy Kestner, Wilbert Meyer, Joyce Meyer, Marcia Messerschmidt, Robert Lively, and Richard Kestner.

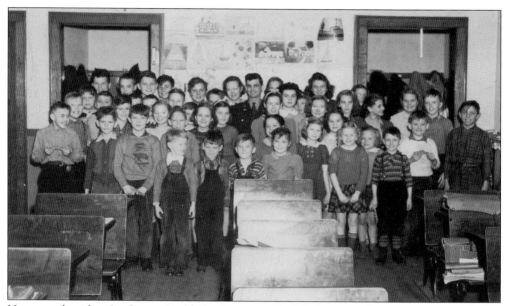

Homewood resident Lt. George Beckhelm (center) of the US Army Air Corps was wounded during World War II while co-piloting a B-17 in a bombing raid over Germany on June 22, 1943. While home during his recuperation, Beckhelm spoke to organizations and school groups including Salem Lutheran (pictured) about his experiences. He returned to Homewood after the war and spent 37 years with the post office before retiring as the village's postmaster.

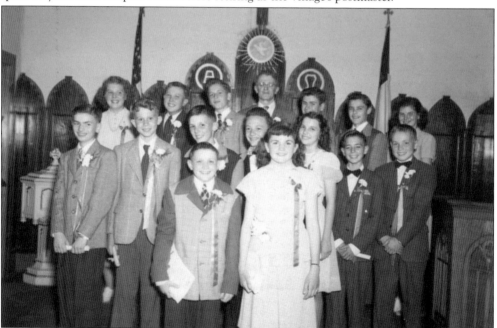

This Salem Lutheran class photograph was taken after graduation ceremonies on June 9, 1947. Pictured from left to right are (first row) John Scott and Marcia Messerschmidt; (second row) Richard Goesel, Lawrence Kellogg, George Thies, Richard Kestner, Norma Fields, Christian Kranz, and Daniel Phelps; (third row) Phyllis Cochrane, Richard Dykstra, Donald Killmer, principal Theodore Ries, Robert Lively, Ronald Tatgenhorst, and June Seelbach.

Four

FAITH OF OUR FATHERS

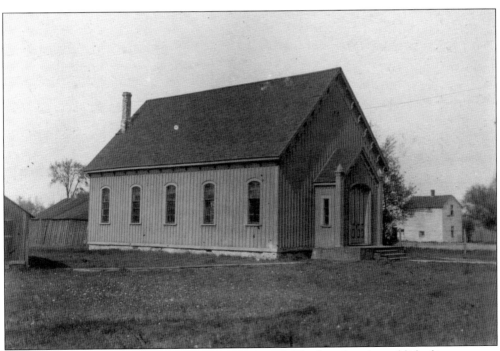

Religious life has always been important in Homewood. The first church established in town was the First Presbyterian Church, which was organized on December 19, 1858. Within months, the congregation completed this church building just north and east of the current intersection of the Dixie Highway and Harwood Avenue.

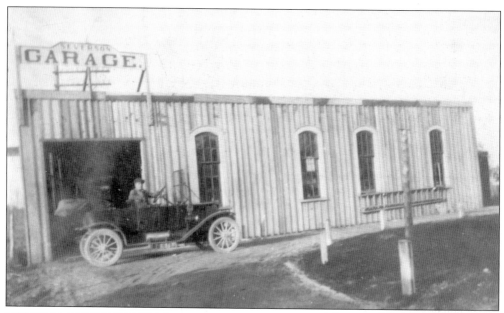

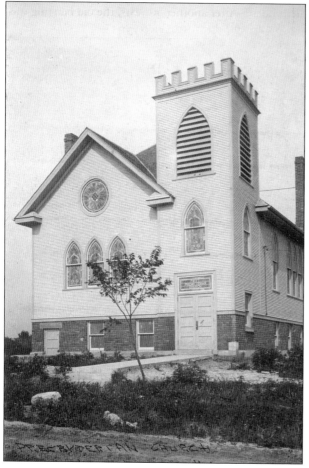

After over 50 years, the Presbyterians constructed a new church in 1915. The original church building was sold to Andrew Severson, who moved it to the southwest corner of the Dixie Highway and Elm Road. Severson ran an auto repair garage in the old church for a short time until he built a new building for his shop.

The Presbyterians purchased property on Gottschalk Avenue and laid the cornerstone for a new church on November 7, 1914. Completed in 1915, the frame building would serve the congregation until 1958, when their current church building was finished in their centennial year.

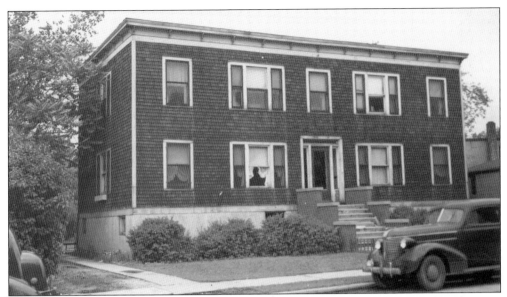

After Andrew Severson built a modern building for his auto repair business, the original Presbyterian church building was again moved south on the Dixie Highway between Elm and Chestnut Roads, enlarged and converted into an apartment house. After another 50 years, the old building was burned down in 1966 to make room for the construction of the Homewood fire station.

Rev. Thaddeus E. Allen, far right on the second row, poses with members of the First Presbyterian Church choir in 1926. Reverend Allen was pastor of the church from 1925 to 1930, and during his tenure, robes were purchased for the adult choir and a junior, or youth, choir was formed. The choirs added immeasurably to church services, and music continues to be an important part of church life.

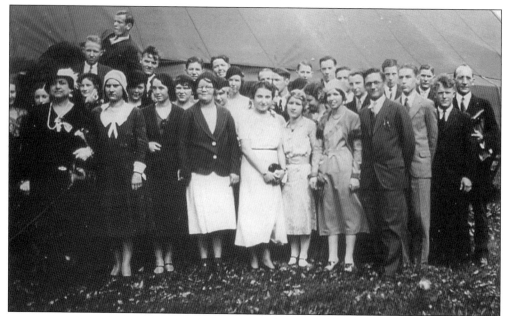

Sunday school students of the First Presbyterian Church pose for this photograph from October 7, 1931. Rev. Wilford Hall Taylor, the pastor of the church from 1930 to 1945, stands far right. Church records show that Sunday school attendance at this time reached about 300 students. A tent was set up south of the church for overflow classes for a short time until alternate space could be found to accommodate the students.

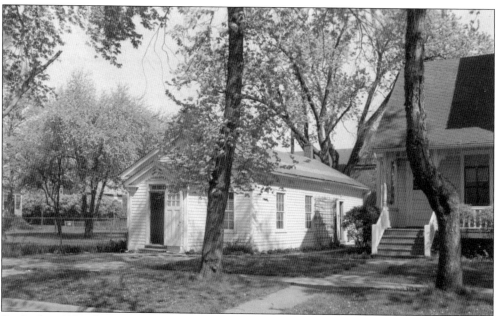

By the late 1850s, large numbers of German immigrants were moving into the Homewood area. Most of them were Lutherans, and they established Homewood's second religious congregation, St. Paul Evangelical Lutheran Church, on May 21, 1865. Services were originally held in this former one-room schoolhouse, which was located on the north side of Olive Road, just west of the Chicago-Vincennes Road (Dixie Highway).

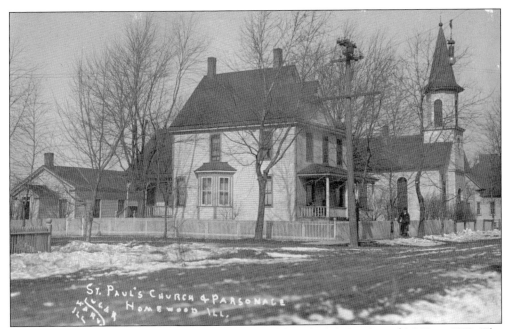

St. Paul Church built a new and larger church building (right) for about $3,000 in 1873. The steeple housed a bell that for years rang out for Sabbath services, tolled for the death of church members and sounded the alarm as Homewood's fire bell. Later, a handsome parsonage (center) was built for the pastor and his family. The former church and original German schoolhouse stand at left in the photograph.

This interior view shows the altar of St. Paul Church. Though St. Paul's church building was relatively small and of typical frame construction on the exterior, the interior sanctuary was more elaborately painted and decorated. With flowers, wreaths, and other flora, the church must have been decorated for a special occasion in this view from 1915.

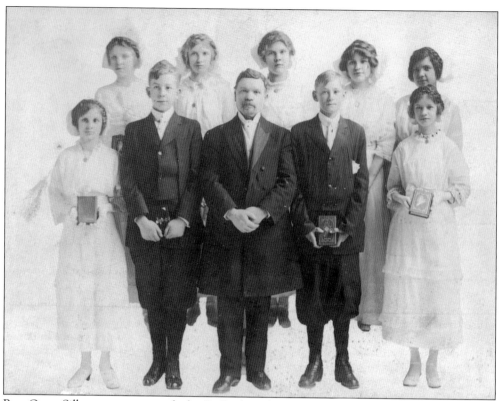

Rev. Oscar Silbermann poses with the St. Paul confirmation class of 1914. In the first row, from left to right, are Elsie Fiebig, Henry Gottschalk, Pastor John Silbermann and Fred Schoof. Others being confirmed were Alvina Brockmann, Dorthea Kaster, Marie Keller, Esther Silbermann, Minnie Schimmel, and Esther Nuessle. Silbermann was pastor at St. Paul from 1911 to 1932.

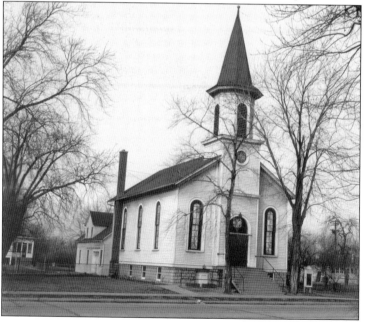

After 50 years, St. Paul Church was enlarged in 1915 to accommodate a growing congregation. The structure was raised three feet off the ground for a basement to be added underneath and the rear of the sanctuary was lengthened 16 feet. The work was completed by the time the church celebrated its 50th anniversary on October 24, 1915.

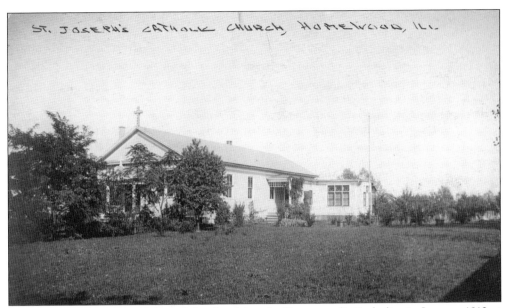

Father Armand Martin celebrated the first Mass for Homewood's Catholics in January 1912 at the Homewood village hall. In June of that year, ground was broken for a new church building on the Vincennes Road (Dixie Highway) across the street from the village hall. This church was completed by the end of September and was consecrated to St. Joseph.

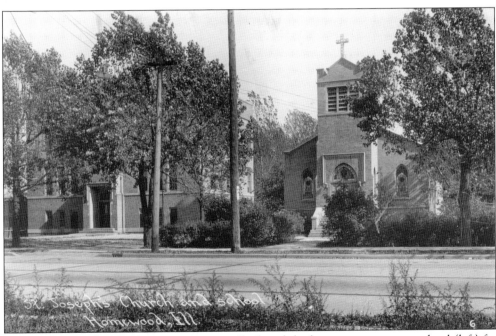

In a little over a decade, the congregation at St. Joseph had grown to support a school (left) for parish children. The school was opened in 1926, and during the time the school was being built, a 24-foot addition was added to the front of the church, which was veneered in brick matching the school and included a steeple topped by a three-foot cross.

63

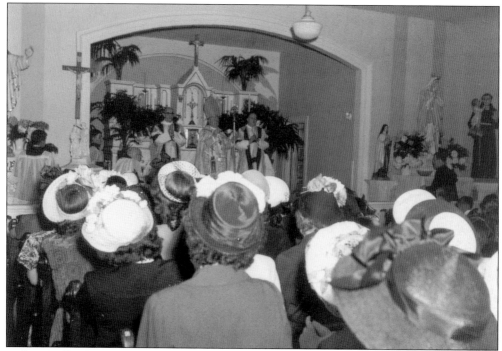

Bishop William O'Brien extends a blessing to parishioners at St. Joseph Church following a confirmation service in the mid-1940s. Parishioners are truly dressed in their Sunday best, and this view also shows a number of devotional statues flanking the decorative main altar.

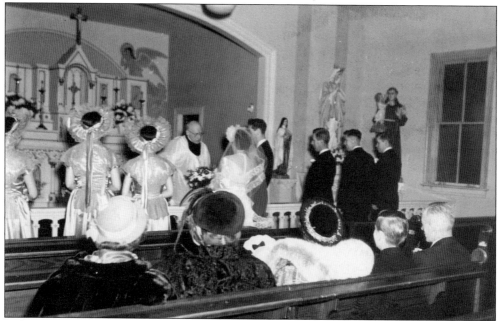

Father Stephen Sullivan officiates at the wedding service of Ray and Dorothy Thomas in 1950. Father Sullivan was the beloved pastor of St. Joseph Church from 1925 to 1955. He was well known throughout the community and ministered to those of all faiths. In recognition of his contributions to the village, he was posthumously inducted into the Homewood Hall of Fame in 2010.

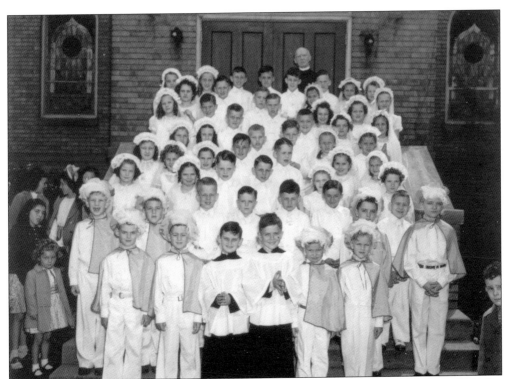

St. Joseph Church experienced rapid growth for decades. In this photograph from the early 1940s, over 50 children received their First Communion, and they pose happily with Father Sullivan for this picture taken on the front steps of the church following the service.

In August 1919, Salem Lutheran Church was organized and affiliated with the Missouri Synod. At first, services were held in a converted carpenter shop on Morris Avenue south of 183rd Street. A new and larger church (pictured) was built in 1925 on the Morris Avenue site and served as home to the congregation for 30 years.

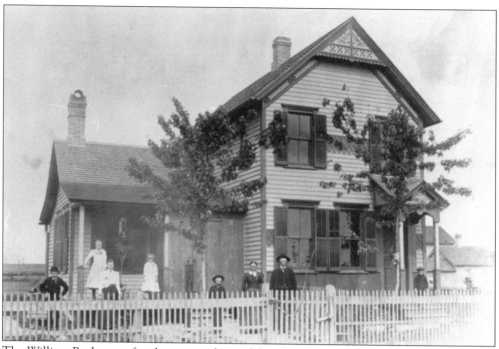

The William Beckmann family poses in front of their home, which was built in the 1890s. The home, later owned by Henry Butze, was sold to Salem Lutheran Church, which was located one lot south, and became the church parsonage in 1941. The house still stands at 18320 Morris Avenue and is a fine example of simple Victorian architecture.

Pastor Walther W. Wilk conducts the wedding ceremony of Otto and Olga Juergens at Salem Lutheran Church on October 31, 1948. Pastor Wilk served the congregation from 1940 to 1971, a time of great growth for the church. During his pastorate, the church on Morris Avenue was replaced by a new and larger building on Ashland Avenue, which was completed in 1955.

Rev. Walther Wilk poses with the Salem Lutheran Church confirmation class of 1947. Pictured from left to right are (first row, seated) Christian Kranz, John Scott, Phyllis Cochrane, Reverend Wilk, Marcia Messerschmidt, June Seelbach, and Daniel Phelps; (second row, standing) Richard Kestner, George Thies, Ronald Tatgenhorst, Donald Killmer, Richard Dykstra, Robert Lively, and Richard Goesel.

Homewood pastors were quite ecumenical and met regularly for coffee to discuss topics ranging from religion to fishing. Rev. Christopher Garriott (left) of St. Paul Church, Rev. Robert Howlett (center) of the First Presbyterian Church, and Father Stephen Sullivan (right) of St. Joseph Church share a laugh in this 1948 photograph.

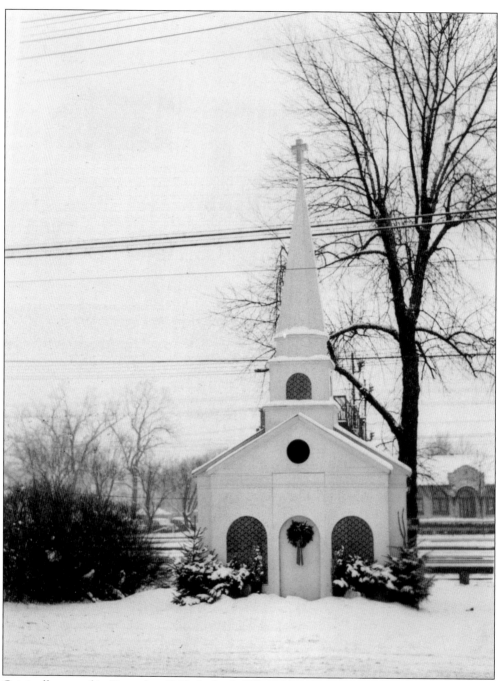

Originally erected in December 1940, the Little White Church stood on the west side of Harwood Avenue at Ridge Road, adjacent to the railroad pedestrian tunnel, for over 30 years during the Christmas season. The idea of civic booster Arthur "Pops" Senior, the "church" had imitation stained-glass windows and a speaker that played Christmas carols. The structure was meant to remind commuters and shoppers of the true meaning of the holiday.

Five

TO SERVE AND PROTECT

Brothers Silas (left), Sidney (right), and Wesley (seated) Briggs were some of the many young men from the Homewood area to fight for the Union in the Civil War. The Briggs boys were raised on a farm that is now part of the Ravisloe Country Club. Here, they visit Lookout Mountain, the scene of a famous battle in Tennessee in which they participated.

James Kentish, holding the flag, leads other World War I veterans in a parade past the old Homewood Village Hall on Chestnut Street in the early 1920s. In all, about 64 Homewood men served during the war. All but four returned home alive.

The monument dedicated for Homewood World War I dead was initially installed on the northeast corner of Main Street (Ridge Road) and Dixie Highway and was dedicated July 4, 1921. In 1923, it was moved to a park next to the village library. The monument now rests with others at the Veterans Memorial Park on Harwood Avenue at Olive Road.

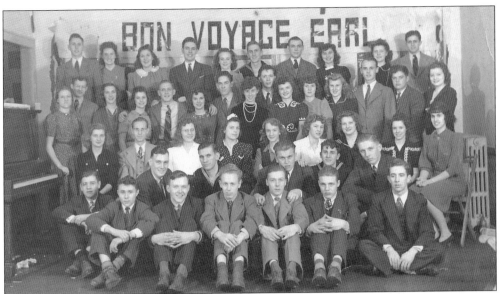

Many friends attended a bon voyage party that was given for Homewood sailor Earl Multog Jr. (back row, center) before he left for service in the US Navy. Little would the partygoers know how things would change the following day. The party was on December 6, 1941—the day before the attack on Pearl Harbor, which led to the country's entry into World War II.

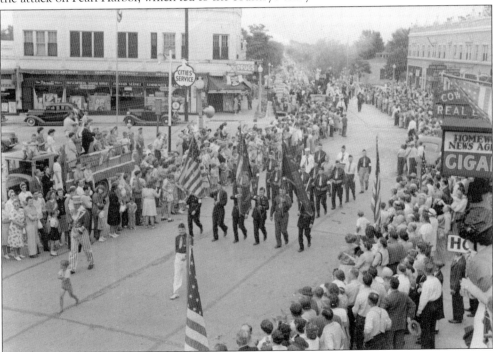

Homewood's Fourth of July parade in 1942 was the first parade held after the outbreak of World War II. Parades helped boost morale and patriotism during the war. Paint store owner Richard Gansbergen (left) as Uncle Sam and Fred Cordt (right), Homewood's funeral director and American Legion Post commander at the time, lead the procession. Marchers are heading west on Ridge Road at Dixie Highway in this view.

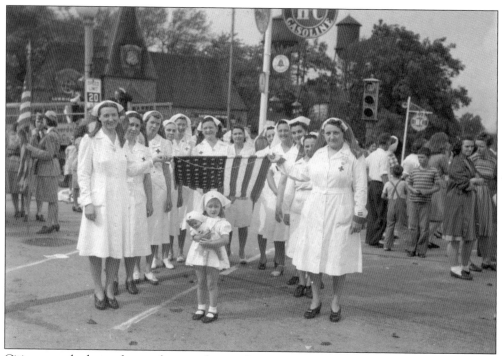

Citizens on the home front volunteered to perform a variety of duties to help in the war effort. The Red Cross helped organize blood drives and roll bandages among other activities. Here, Homewood's Red Cross volunteers muster for a parade at Ridge Road and Dixie Highway during World War II.

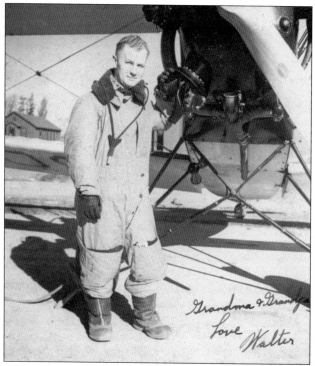

Walter "Wally" Burns was the first from Homewood to give his life in World War II. Too short for the US Army Air Corps, Burns enlisted in the Royal Canadian Air Force (RCAF) in October 1940 and was killed when the RCAF bomber he was piloting crashed on July 13, 1942, in North Africa.

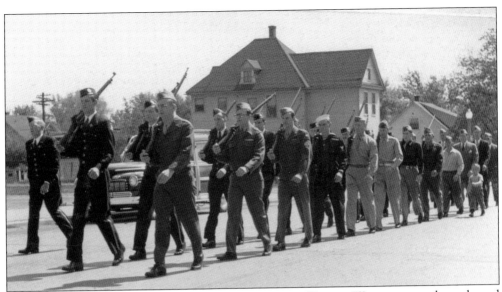

Members of Homewood's American Legion and Veterans of Foreign Wars posts march westbound on Ridge Road just east of Dixie Highway in the 1948 Memorial Day parade. In Homewood, the American Legion post was organized in December 1919 by World War I veterans, and the VFW post was established in August 1946 by veterans returning from World War II.

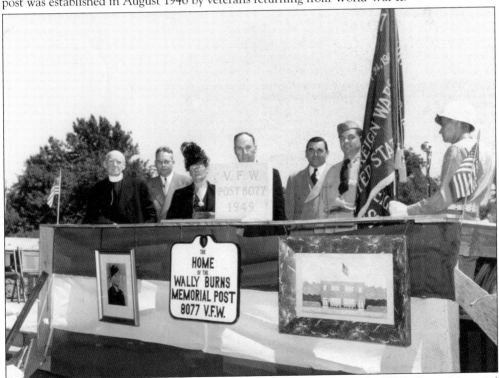

Cornerstone-laying ceremonies were held on Memorial Day 1949 for the Wally Burns Memorial Post of the Veterans of Foreign Wars. The VFW post was located at 18147 Harwood Avenue, now Grady's Snack N' Dine restaurant. From left to right are Rev. Stephen Sullivan, Rev. C.T. Garriott, Mary Burns, William Burns, Rev. Robert Hollett, and post commander Arthur Welsh.

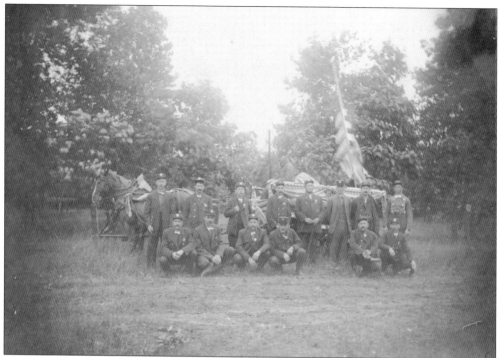

The Homewood Fire Department was organized on January 6, 1896, with 23 volunteers and a hand-drawn, hand-operated pumper. By 1907, the department was equipped with this horse-drawn combination hand and chemical engine. Department members proudly pose in front of this engine before a village parade.

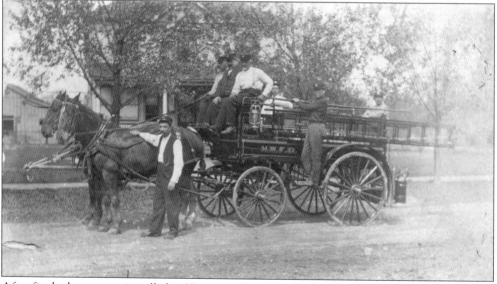

After fire hydrants were installed in Homewood in 1911, the fire department purchased this two-horse hose wagon. Pictured from left to right are Joe White, Elmer Farmer, Fred Gold, William Buggert, Henry Stolzenbach, Henry Duwe, and George Kern. The photograph was taken in front of the Fred Gold home, formerly the Ryan Funeral Home and now the Homewood Science Center on Dixie Highway.

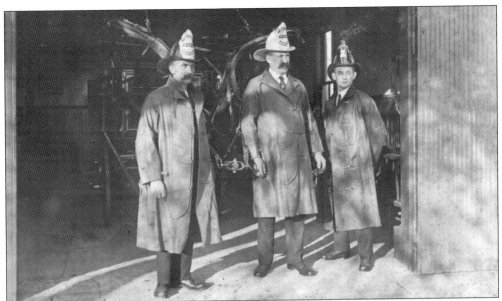

Joseph White (left) and Carl Steiner (center) were long-serving early volunteer firefighters. White served as fire chief from 1915 to 1927, and Steiner was chief in 1901. The two pose in front of the firehouse with another volunteer in the long rubber coats and leather helmets that provided protection to early firefighters while battling blazes.

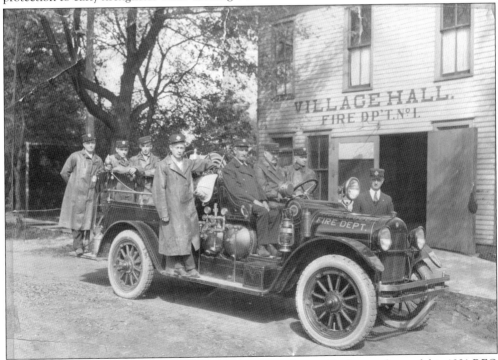

The Homewood Fire Department entered the motorized era with the purchase of this 1921 REO chemical wagon. In addition to ladders and hose, the rig carried two tanks filled with water and soda. Pictured from left to right are Herman Meyer, Tom White, Fred Gold, Alvin Gold, Joe White, Carl Steiner, Henry Duwe, and William Warning.

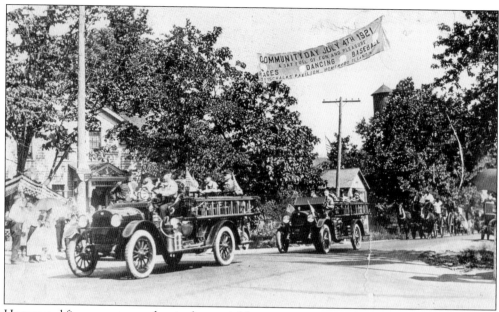

Homewood fire apparatus and units from neighboring communities lead the 1921 Fourth of July parade south on Dixie Highway at Main Street (Ridge Road). The water tower located behind the original village hall is visible in the background. Independence Day parades have always been a tradition in Homewood and have been accompanied by a community picnic for years.

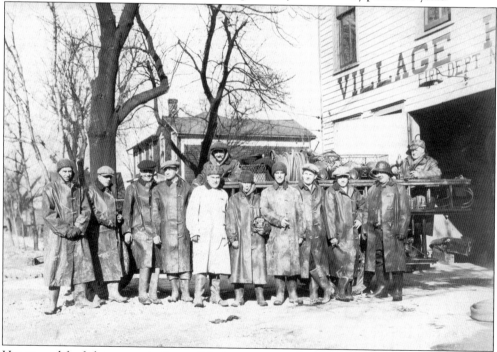

Homewood firefighters pose in front of their quarters in the old village hall on Chestnut Road, likely after a winter fire call in the late 1920s. Chief William Bennett, who served as chief from 1927 to 1929, is in the white coat near the center of the photograph. Interestingly, many of the firefighters pictured are holding cigars.

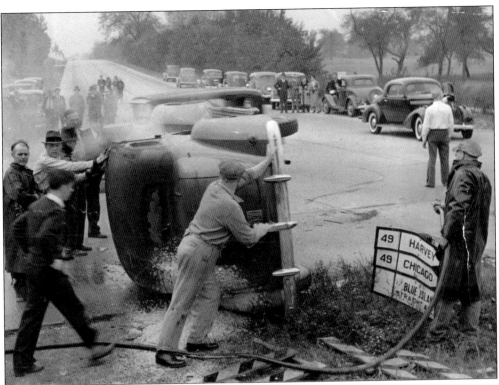

Homewood firefighters and a group of bystanders work to extinguish a car fire following this accident in the 1930s at the intersection of what today is 175th Street and Dixie Highway. Volunteer firefighters frequently reported directly to the scene of an emergency and worked without the benefit of protective clothing. This view looks west on 175th Street, and Calumet Country Club is to the right.

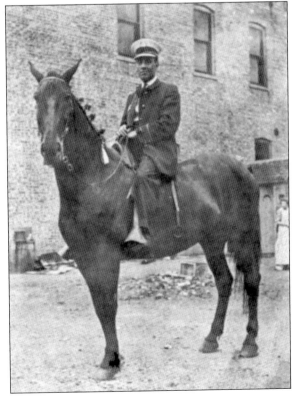

Walter Gleason was Homewood's first policeman and served on the department from 1902 to 1951. During his early years on the force, Gleason was the only officer, and crime was infrequent. Much of his time was spent patrolling the community on foot, but he did use a horse when needed.

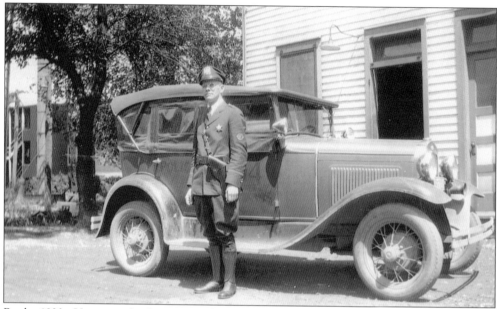

By the 1920s, Homewood police acquired a squad car to patrol the village, and officers no longer had to use their own cars or borrow one to attend to calls. This was a welcome improvement for all residents. Here, officer Albert Toberman poses beside the police department's 1930 Ford Model A.

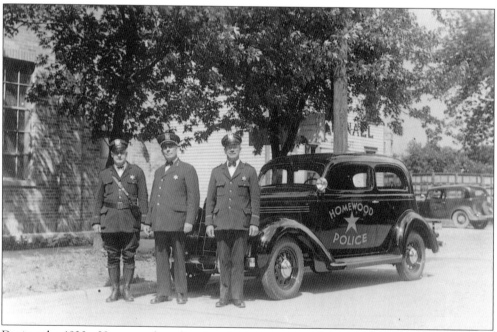

During the 1930s, Homewood's police department was a small but effective force. From left to right, Ofc. William Utermark, Chief Walter Gleason, and Ofc. Albert Toberman were charged with protecting the lives and property of the village's citizens. Sgt. Fred Nyquist, who patrolled during the midnight shift, is not pictured.

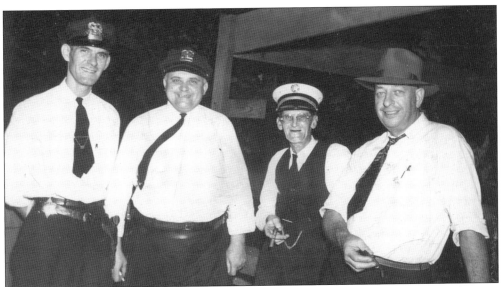

At special events like parades, carnivals, and other well-attended activities, auxiliary policemen augmented the full-time police force to maintain order. Ted Utermark (left), a volunteer fireman and gas station proprietor in town, was one of the auxiliaries. Fire chief Nick Kuhn, who served in that role from 1930 to 1955, is also pictured second from right.

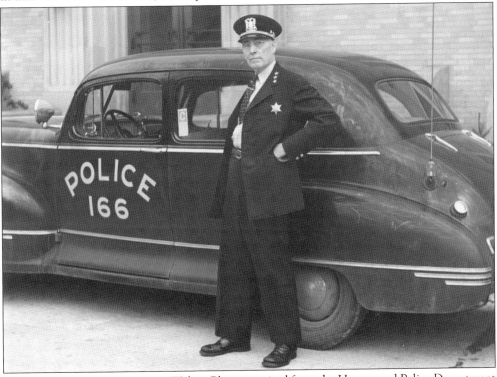

After almost 50 years of service, Walter Gleason retired from the Homewood Police Department in 1951. He was the department's chief from 1904 to 1951 and also served as a volunteer firefighter from 1901 until 1951. During his early years, he also was the village's water superintendent and health officer, among other duties he was assigned.

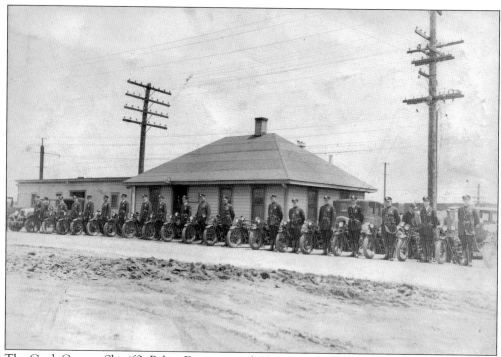

The Cook County Sheriff's Police Department had a presence in Homewood for over 50 years. Since 1922, deputies reported to a station, which included a remodeled boxcar located on Dixie Highway just south of 175th Street. In this interesting view, about 20 deputies pose with their motorcycles in front of the rather simple quarters they occupied in Homewood during their early years here. (Courtesy of Michael Brooks.)

In 1937, this building at 1154 Ridge Road was completed and served as the south headquarters for the sheriff's police. It had offices, a lock-up, courtroom on the first floor, and a garage for squad cars on the lower level. The sheriff closed this facility in 1975, and it now houses the emergency dispatch center for Homewood and six neighboring communities.

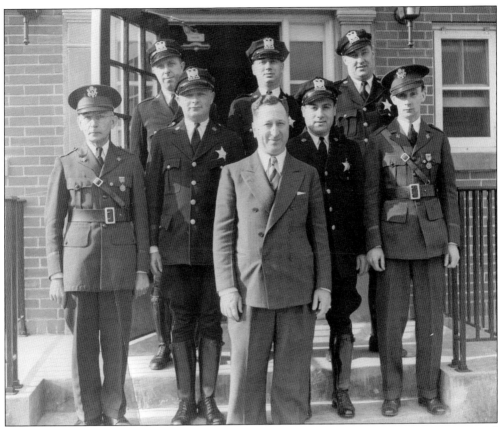

Lt. Fred Mulhausen, in suit, was the commander of the Cook County Sheriff's Office in Homewood for a number of years. Here, he poses with a group of sheriff's deputies under his command in front of the Ridge Road headquarters. From the 1920s to the 1940s, Mulhausen and his men patrolled vast stretches of unincorporated territory in the south suburbs before these suburbs grew after World War II and expanded their own police forces. (Courtesy of Fred Mulhausen.)

After incorporating in 1893, Homewood completed construction of its first village hall in 1894 on Clark Street (now Chestnut Road). A simple wood-frame structure, a large meeting room on the second floor was used for village board meetings and other community events, and the village clerk and the police and fire departments occupied space on the first floor.

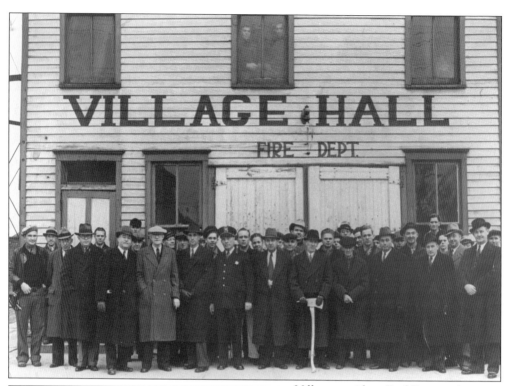

Village president Fred Borgwardt stands with axe in hand posing with other village officials and residents in front of the village hall just before the old building was torn down on December 5, 1938, to clear land for the construction of a new municipal building. The old frame building had served as the seat of local government since 1894 and could no longer accommodate the space needs required by the village.

Village president Fred Borgwardt (center-left, facing camera) officiates at the cornerstone laying ceremony of Homewood's current village hall on March 4, 1939. The building was completed at a cost of $135,000 with the assistance of Depression-era Public Works Administration (PWA) funding from the federal government.

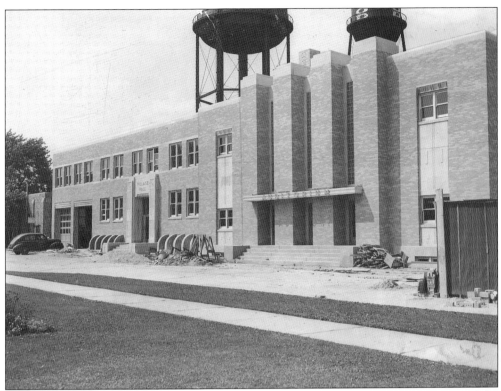

Homewood's current village hall was completed in August 1939 and housed village offices and the police and fire departments. In addition the building amenities included a 300-seat auditorium with basketball court, stage, and kitchen for community functions and entertainment. After almost 80 years, the building still serves as the center of village government.

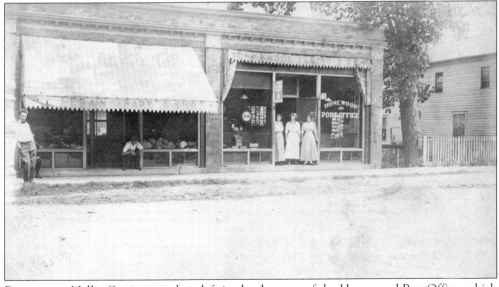

Postmistress Nellie Cowing stands at left in the doorway of the Homewood Post Office, which was located on Main Street (Ridge Road). Cowing served as postmistress from 1899 to 1925. Built in 1908, it still stands at 2048 Ridge Road. A second floor was added in 1915.

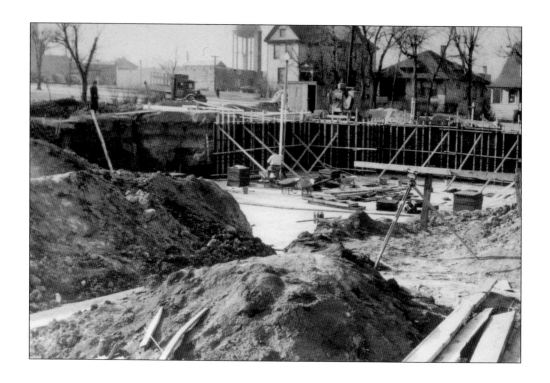

Excavation work proceeds for construction of a new Homewood Post Office building at 1921 Ridge Road. Ground breaking for the facility took place in January 1940, and it was dedicated on October 26, 1940. Built at a cost of $75,000, this was another village project funded by the federal Public Works Administration (PWA). The building still serves as the village's postal facility.

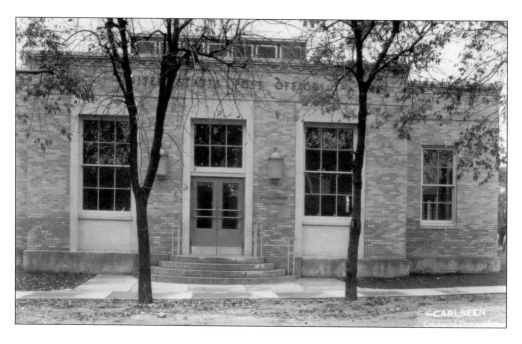

Six

FUN AND GAMES

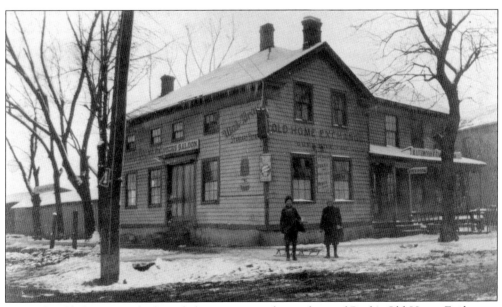

A couple of lads pose with their sleds on a snowy day in front of Beck's Old Home Exchange, which was located on the southwest corner of the Chicago-Vincennes Road (Dixie Highway) and Main Street (Ridge Road). Constructed in 1855, it was one of the first buildings in Homewood. It housed a tavern and hotel that was used by travelers and locals alike. Over the years, a number of owners ran the business and Gus Beck was the proprietor when this picture was taken in the early teens. The building was moved to the lot directly to the south in 1924 to allow for the construction of the building that continues to occupy the corner today.

On another snowy day, Lucy Granniss rides this unique sleigh powered by her St. Bernard south on Martin Avenue. The Gottschalk house is in the background in this view from about 1900. Lucy, born in 1894, lived with her parents Thomas and Theresa on Martin Avenue and was a lifelong Homewood resident. She married Henry Puhrmann in 1919 and lived to the ripe old age of 90.

Stanley and Harry Gottschalk, sons of Henry Gottschalk, take a ride with their pony and buggy. This picture was taken in front of the family home, which still stands at 18101 Martin Avenue and is one of two historic landmarks recognized by the village of Homewood. Visible to the right of the horse are carriage steps that made it easier for passengers to get in and out of a buggy or carriage.

A group of children gather in the late 1920s for a winter sleigh ride at Salem Lutheran Church, seen center. The church parsonage is pictured at right, and Salem Lutheran School is just visible at left. The sleigh was powered by Charlie Wolf's team of horses. Like hayrides in the summer, sleigh rides were a popular winter activity when snow was plentiful and the streets were not plowed.

Doepp's Pond was located on the grounds of the Dr. William Doepp home on the Chicago-Vincennes Road (Dixie Highway) and allowed youngsters, like these girls in early swim suits, to cool off during the summer months. In winter, it was a good spot to ice skate. The steeple of St. Paul Church is visible in the background. By the mid-20th century, the pond was filled in and is now covered by a parking lot.

Hunting was a popular pastime for many village residents. Prior to the building boom of the 1950s, Homewood was surrounded by farms and open land that supported wildlife and allowed for good hunting. Looking like he is out of a scene from the Wild West, William Jaynes poses with some of his quarry. Jaynes lived on a farm at 175th and Halsted Streets, where Menards is located today.

In the late 1890s, Henry Gottschalk converted a grove east of the rail tracks into picnic grounds, and a pavilion was built for dances and other events. Later, Gottschalk's Pavilion was used as a roller rink. By December 1940, the pavilion was gone and the grove was purchased by the Homewood Businessmen's Association and donated to the village for a park, which was appropriately named Merchants Park.

Band concerts were frequent sources of entertainment in Homewood during the late 19th and early 20th centuries. Most towns had community bands, and Homewood was no exception. Many performances were held at Gottschalk's Pavilion or on the grounds of the Homewood rail depot. Band members pose in this photograph following a summertime event and appear to be quenching their thirst with bottles of a local brew.

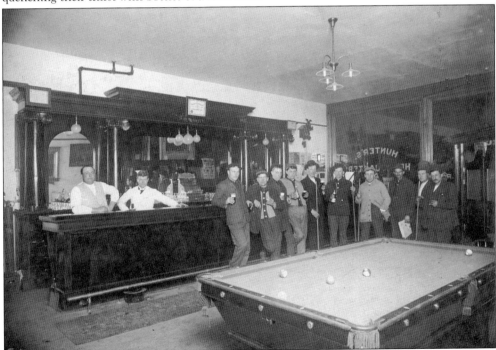

William Brutlag (left) and Fred Koehrmann stand behind the bar in the tavern Brutlag built on the southwest corner of Maria Street (183rd Street) and Morris Avenue in 1908. He and his wife, Sophie, operated the tavern until Prohibition took effect in January 1920. This was a good place for locals to relax and catch up on the news. Patrons take time out from a pool game to pose for this picture.

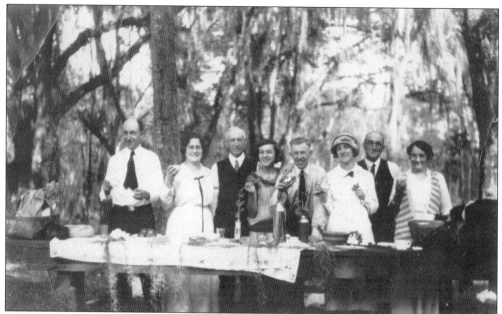

Fred O. Multog and his wife, Minnie Bang Multog (left), and Ed Bang and his wife, Mamie Multog Bang (right), pose with family members at a picnic in the early 1920s. Bang was an ice dealer in Homewood for a number of years, and after the widespread use of mechanical refrigerators in the 1920s, he closed up shop and did what any iceman would do—move to Florida.

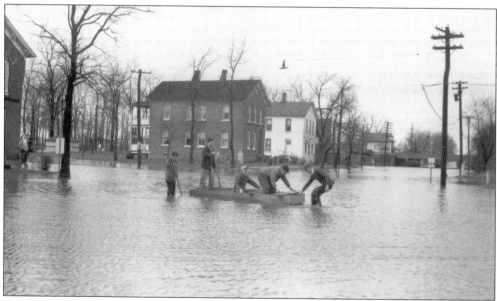

Out for some improvised fun, a group of teenagers maneuver a makeshift boat through the flooded intersection of 183rd Street and Harwood Avenue following a May 1947 storm. For decades, the intersection and railroad viaduct were notorious for flooding following rainstorms. Fortunately, drainage improvements have solved this problem. Blueberry Hill Restaurant occupies the building in the center of the photograph.

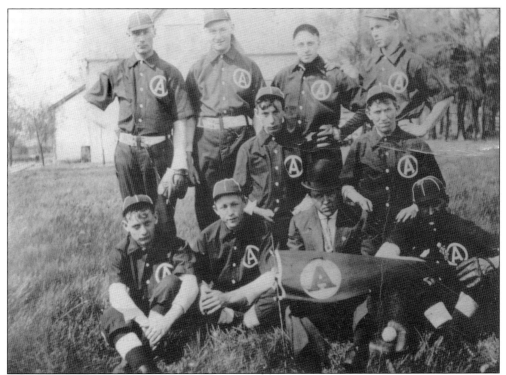

Baseball is America's pastime and has always been a favorite in Homewood. In addition to teams sponsored by local merchants, the Homewood Athletic Club fielded its own team named the Circle A's, which played against teams from other towns. Pictured from left to right (first row) Alvin Gold, Ed Scupham, Fred Gold, Henry Fiebig, Jack Fiebig, and Jack Rehberg; (second row) Henry Dorband, George Moecker, Louis Mueller, and E. Gilbert.

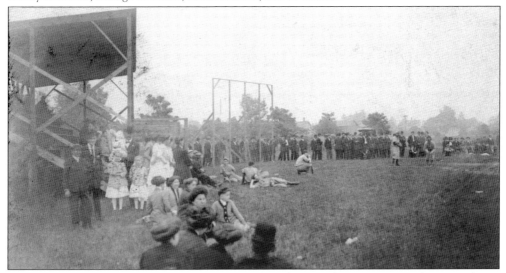

Baseball games were played on an improved hayfield south of 183rd Street just east of Dixie Highway. Though primitive by today's standards, the ball field grounds in Homewood were complete with covered bleachers, backstop, and a small concession stand. Attending a ballgame was a real social event, and the dress for a game, according to this image, was not as casual as it is today.

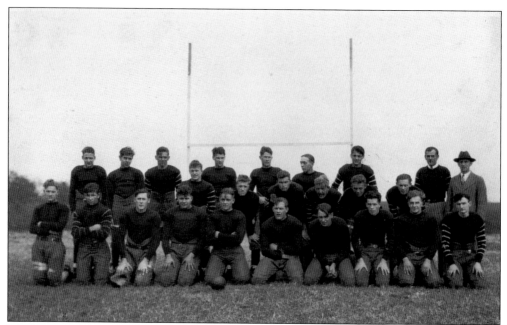

The Homewood Athletic Club also had a football squad, who were champions in 1929. Pictured from left to right are (first row) Tom Smith, Fred Domm, Larry Nelson, George Hrncsjar, Eddie Hansen, Al Hagen, Everett Riegel, Kenneth Seator, Henry Suhs, and Gilmore Jennings; (second row) Arnold Carroll, Bob Dainton, Roy Auguston, Bill Hedtke, Robert Kentish, and Bob Peterson; (third row) John Behrendsen, ? Gilrie, Norman Morgan, Lawrence Cadieux, August Auguston, Bill Pollmacher, Vernon Cadieux, manager Charlie Wolf, and coach Marty Sodetz.

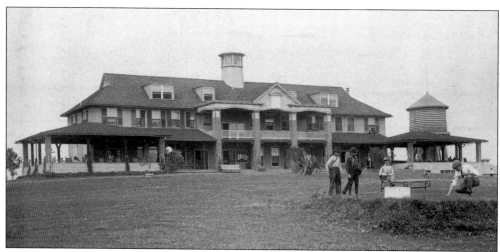

Golf has always been a major influence in Homewood. The first golf club established was the Homewood Country Club, officially chartered in 1899. Construction was completed in 1900 on their first clubhouse, a large two-story frame structure located southeast of the present-day intersection of Flossmoor Road and Western Avenue. The building was struck by lightning and burned to the ground in May 1907.

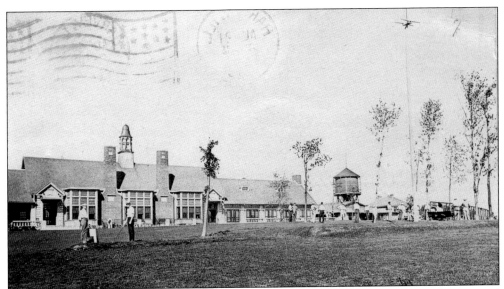

Homewood Country Club's second clubhouse was rebuilt on the same site in 1908 and was touted as "fireproof." Unfortunately, lightning struck again, and the second clubhouse was leveled in a May 1914 fire. Hoping to prevent further trouble with Mother Nature, the present clubhouse, completed in 1916, was built a half mile south of the original site, and the club changed its name to the Flossmoor Country Club.

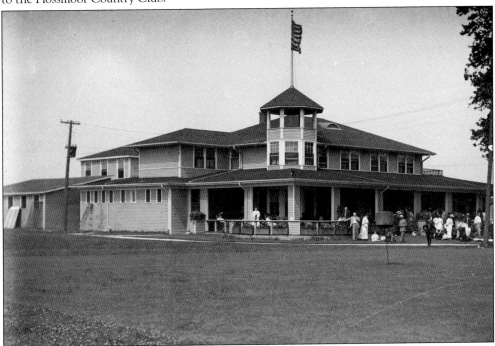

Organizers of Ravisloe Country Club purchased the Sidney Briggs farm in August 1901. The farm was located north of Maria Street (183rd Street), just west of the Illinois Central depot, allowing members from the city to easily visit the course. Five holes were playable that fall, and the remaining holes were developed the following year. After using the farmhouse for temporary quarters, the first clubhouse (pictured) was built in 1902.

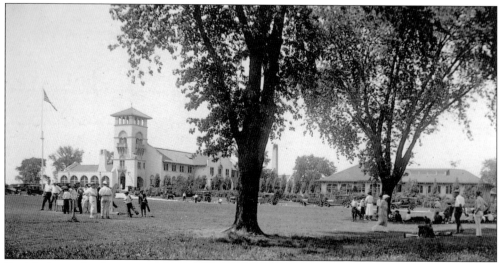

Ravisloe's membership outgrew their first clubhouse and construction of a large Spanish Revival structure, the current clubhouse, began in 1916. When completed, it was one of the most luxurious in the country. Ravisloe Country Club remained private until 2009, when veterinarian Dr. Claude Gendreau bought the course and opened it to the public. The club is well patronized and continues to remain a jewel of Homewood.

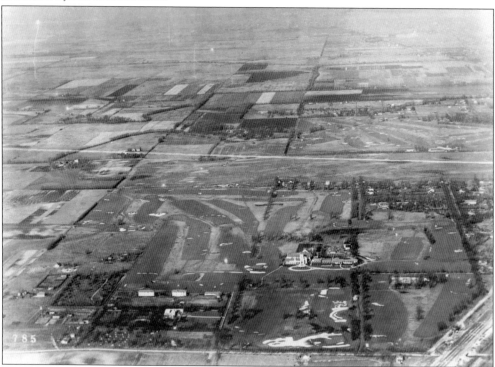

This 1924 aerial view of Homewood (looking north) shows Ravisloe Country Club in the foreground. Calumet Country Club is visible toward the center-right of the photograph, while downtown Homewood is just out of view on the right. The image illustrates just how much the village was surrounded by farmland at the time and would remain so until the post–World War II housing boom.

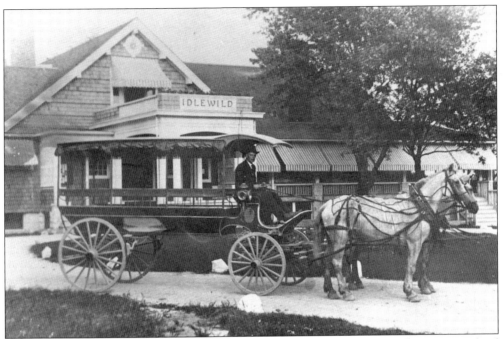

Idlewild Country Club was incorporated in 1908 and built just south of the village limits on land that was homesteaded by Benjamin Butterfield in 1838 and was later the farm of William and Henry Gottschalk. Being a distance from the train station, the club used this horse-drawn "station wagon" to shuttle members from the depot during the golf season. Elmer Farmer is at the reins.

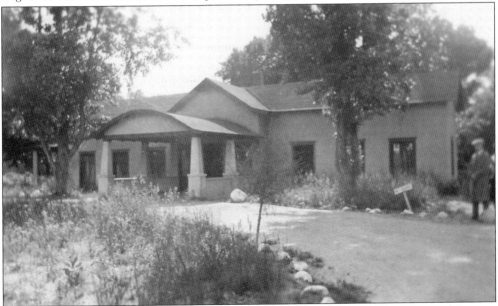

Calumet Country Club was established in 1901 in Chicago at Ninety-Fifth Street and Cottage Grove Avenue on property now occupied by Chicago State University. The club purchased a 126-acre tract of land on 175th Street, just west of the Dixie Highway, from August Steiner in February 1917 and moved to Homewood that year. Donald Ross was contracted to design the course, and this building was built as the clubhouse.

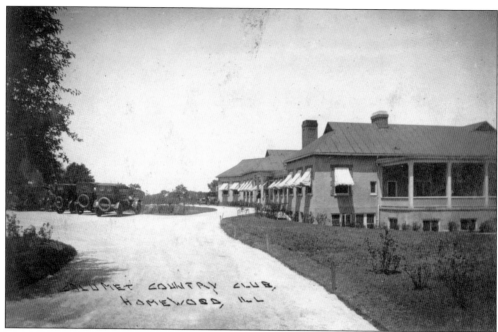

By 1921, members of Calumet Country Club had settled into their Homewood location and embarked on a program to improve their facilities. As part of this program, the clubhouse was significantly enlarged and remodeled. This same clubhouse, although extensively renovated over the years, still serves Calumet's members today.

Dixmoor Golf Club was incorporated in October 1921 and built on the 123-acre Jabez Howe farm, situated south of 175th Street, and west of the Dixie Highway, directly across from the Calumet Country Club. Dixmoor was a semiprivate club and was open to the public for play. Never a financial success, the club closed in 1926. The land was sold to a developer and is now the Governors Park subdivision.

Robert White, a Scottish immigrant and the first golf pro at Ravisloe Country Club, was also an accomplished golf club maker. In 1908, he organized a cooperative of club makers named the P.G. Manufacturing Company in Homewood. The group's facilities were located on the northwest corner of what today is Ridge Road and Park Avenue, west of the rail tracks. The company operated until 1914.

With Dixmoor and the four country clubs operating in Homewood, brothers Urban, Martin, and Eddie Klin saw potential and started the Klin Brothers Golf Manufacturing Company to supply golf clubs to the market in the Chicago area. In 1922, they rented the then vacant flourmill from the Steiner family and produced Klin "Drive Rite" clubs in Homewood until 1926, when they moved production facilities to Valparaiso, Indiana.

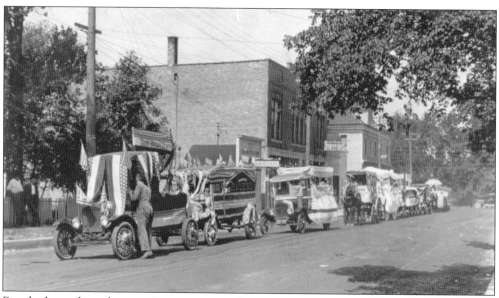

Parades have always been an important part of community activities in Homewood. In addition to the Fourth of July and Memorial Day parades, at one time or another, the village has also had parades to commemorate Fire Prevention Week and high school homecomings among other events. In this view, both motorized and horse-drawn floats line up on Main Street (Ridge Road) for the village's July 4, 1921, parade.

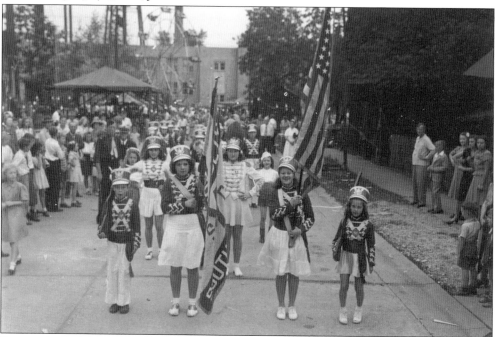

During the early 1940s, Homewood's Fourth of July parade was held in conjunction with the Homewood Homecoming, a multi-day celebration that included the parade, a carnival, dances, and other activities. In this view, a drum and bugle corps poses on Martin Avenue just north of Ridge Road for one of these events. Carnival rides and other amusements can be seen in the background in front of the village hall.

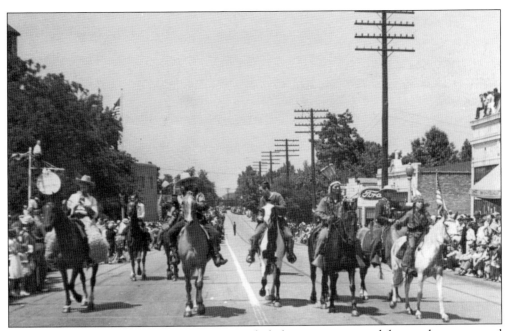

The 1940 Homewood Homecoming was a particularly festive occasion, and the parade was reported to be the largest Homewood ever had. Sponsored by the businessmen's association, fire department, and American Legion, the event had a western theme, and the parade even included "cowboys and Indians" on horseback. Here, the riders are heading south on Dixie Highway approaching the Ridge Road intersection.

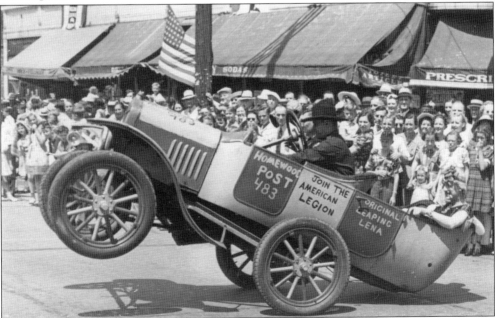

The American Legion's "Leapin' Lena" was another favorite during the 1940 Homewood Homecoming. A modified Ford Model T, the car performed a variety of stunts during parades to the delight of bystanders. Here, Legion members put Lena through the paces in front of a crowd three deep at the intersection of Dixie Highway and Ridge Road.

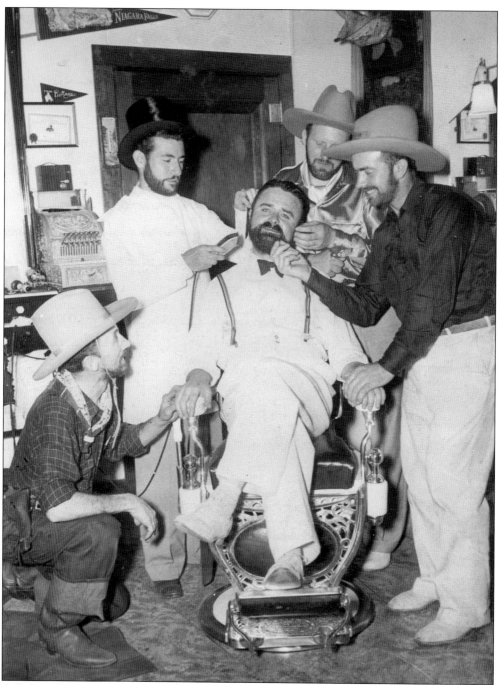

Another event of the 1940 Homewood Homecoming was the beard-growing contest. Men of the village were encouraged to enter the contest, which required they not shave for the month before. Judging was done on the last day, and Edward Gitersonke, a Homewood grocer, was the winner. In this view, barber Ray Miley begins to shave off Gitersonke's beard while, from left to right, Frank Wolfenberger, Clarence Langhout, and Jack Kurtz look on.

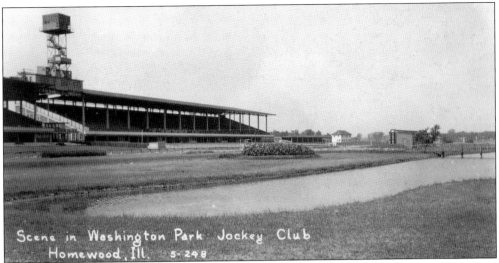

Scene in Washington Park Jockey Club
Homewood, Ill. 5-248

The Washington Park Corporation and the Illinois Jockey Club built Washington Park Race Track on the west side of Halsted Street, south of 175th Street. Situated on 206 acres, construction started in the spring of 1924. Facilities included a massive steel and concrete grandstand, clubhouse, judges' stand and paddock area. Thirty stables capable of accommodating over 1,000 horses were also built.

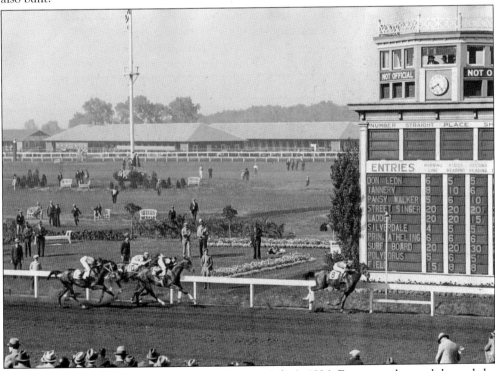

Inaugural races at Washington Park took place on July 3, 1926. For years, the track hosted the American Derby and a number of other historic races, including the 1955 match race between Swaps and Nashua. After an evening of winter harness racing, the track's grandstand burned down in a spectacular fire on February 5, 1977, and was never rebuilt. Here, Gold Step crosses the finish line on May 23, 1932.

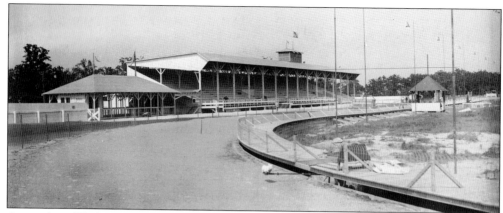

Across from Washington Park Race Track, on what is now the northeast corner of 175th and Halsted Streets, the Illinois Kennel Club built a greyhound racetrack. In addition to the grandstand and paddock areas, the track had kennel facilities for over 300 greyhounds and was lighted by several half million-candle power floodlights. Like Washington Park Racetrack, the dog track held its inaugural races on July 3, 1926.

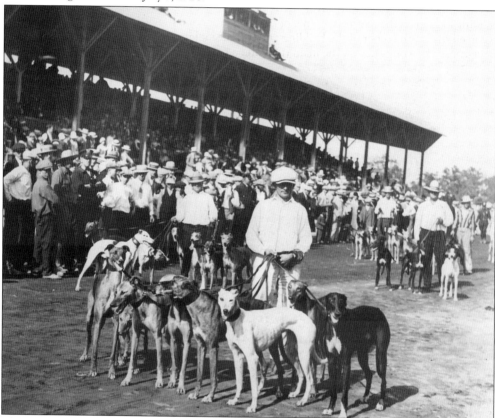

The dog track, later known as the Thornton Coursing Club, like other dog tracks in the Chicago area, was the subject of legal battles that prohibited pari-mutuel betting on dog racing. Despite efforts by track operators to get legislation passed to allow betting, these efforts failed, making dog racing illegal in Illinois. The track closed in 1934. News reports at the time indicated the track had been "allied with Capone interests."

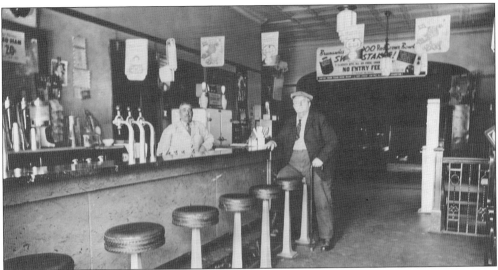

Fred and George Hartmann opened the Homewood Recreation Parlor in the "Dixie-Ridge" building located on the southeast corner of Dixie Highway and Ridge Road in 1929. The business occupied the south corner of the building and included a lunch counter and soda fountain and an eight-lane bowling alley on the main floor and a billiards and pool hall in the basement.

Fred and Nell Hartmann pose with the Homewood Recreation Parlor's entry for Homewood's July 4, 1941, parade in front of the business at 18061 Dixie Highway. Nell was captain of a women's bowling team that travelled to competitions across the country. The team was sponsored by Rovick Bowling Shoes and used the Homewood bowling alley as their headquarters. The team won the 1941 women's world championship in Los Angeles.

For most of the Depression years, Homewood was without a movie theatre. Residents went to Harvey, Chicago Heights, or other towns to see the newest films. This changed when the Homewood Theatre opened on November 23, 1937. The 659-seat "air-cooled" theater was constructed by remodeling the shuttered Heuer's Service Garage located on Dixie Highway just south of Ridge Road.

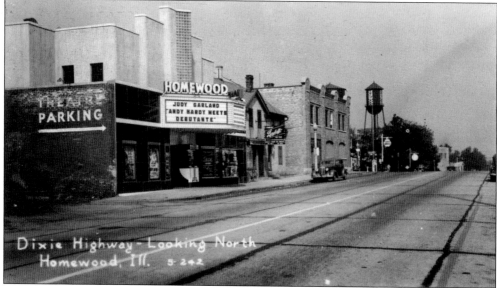

The Homewood Theatre was a main fixture on the west side of Dixie Highway. Patrons came from Homewood and neighboring communities and the feature film changed weekly. This picture was likely taken in the summer of 1940, as the film advertised on the marquee was released in July of that year. The theater operated until 1984 and was demolished in the spring of 1992.

Seven

COMMERCE AND INDUSTRY

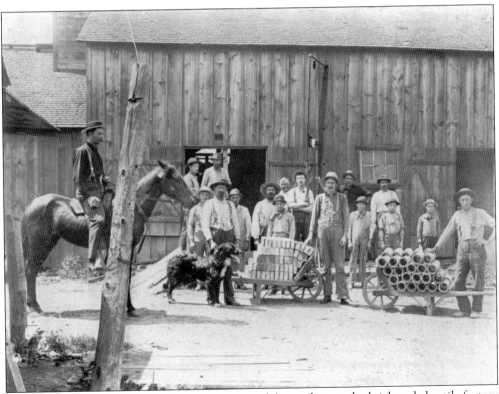

Henry Gottschalk, on horseback, oversees some of the workers at the brick and clay tile factory he owned in Homewood. The factory was located near where Flosswood Condominiums now stand. Henry took over the business from his father, William, and his partner in 1886. The brick and tile works was in operation until about 1912. Prior to the advent of child labor laws, young boys often worked at the factory in its early years.

William Gottschalk (left) and his son-in-law August Witt, wearing a white shirt, stand in front of the dry goods store Witt ran in Homewood. The store was located on the northeast corner of Main Street (Ridge Road) and Martin Avenue. A number of "locals," including children, pose for this photo from the 1880s. The building, renovated and enlarged over the years, still stands and is one of the oldest in town.

William Buggert (left) and his father Christian stand in the doorway of their blacksmith shop with their family. The shop, built in the late 1850s, was located on the southeast corner of Main Street (Ridge Road) and the Chicago-Vincennes Road (Dixie Highway). In addition to repairing wagons and carriages, the Buggerts were dealers for the Schuttler and Ottawa Wagon Companies and the Plano Harvester Machinery Company, the predecessor of the International Harvester Company.

John Kaehler (left) stands in front of his blacksmith shop located on Harwood Avenue just north of Chestnut Road. The shop was built in 1892 by William Horn, who later sold it to Kaehler. Kaehler operated the business until 1916 when he sold the building to Bernard Eisle and the blacksmith business to R.S. Flowers. The old shop was torn down in 1940. (Courtesy of Marsha Lockwood.)

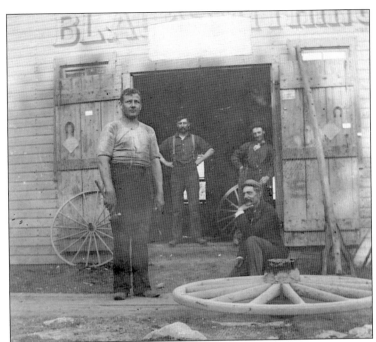

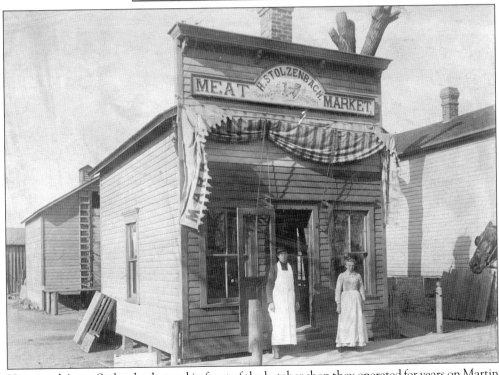

Henry and Anna Stolzenbach stand in front of the butcher shop they operated for years on Martin Avenue, a block south of Main Street (Ridge Road). Stolzenbach purchased the shop in 1881, and his sons Albert and George succeeded their father and operated the meat market until they retired in the late 1940s. The building survived as a quaint reminder of Homewood's past until it was torn down in 1997 for a condominium project.

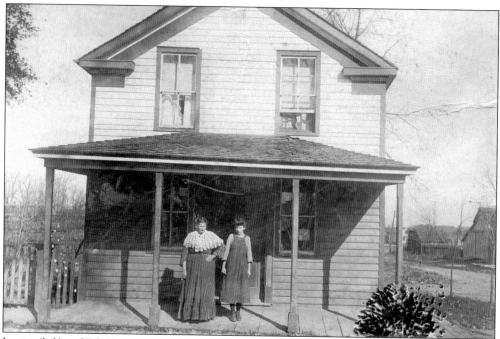

Louise (left) and Eda Duwe pose in front of the family harness shop, located on the on the northwest corner of Main Street (Ridge Road) and Martin Avenue. Harness maker William Duwe would ply his trade at this location from 1874 until his death in 1920. The family, which grew to include nine children, lived on the second floor. LaBanque Hotel occupies the site today.

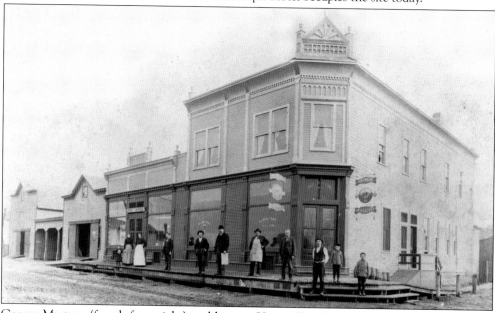

George Mertens (fourth from right) and his son Henry (fourth from left) pose in front of the family businesses, which were located on the southeast corner of what is now Ridge Road and Harwood Avenue. On the corner, Mertens ran a saloon and hotel. To the east, son Henry ran the family general store, which also doubled as the post office during his term as village postmaster from 1897 to 1899.

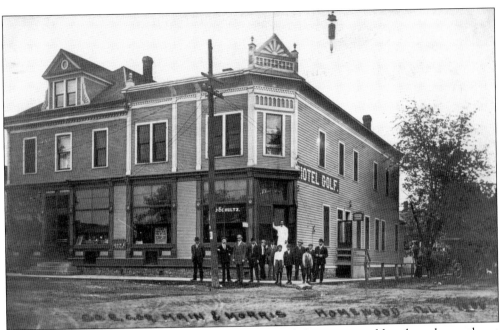

By 1910, John Schultz, standing in the doorway, owned the tavern and hotel on the southeast corner of Main and Morris Streets, now Ridge Road and Harwood Avenue. Schultz catered to golfers from area courses in season, hence the name Hotel Golf. Henry Funk operated the general store in the building next door, which had a second floor added in 1905.

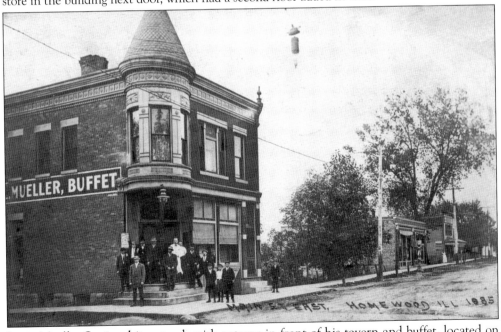

Louis Mueller Sr., in white, stands with patrons in front of his tavern and buffet, located on the northeast corner of Main and Morris Streets, now Ridge Road and Harwood Avenue. The building survives, but the second floor and turret were removed, an addition was put on the front, and the exterior was stuccoed in a 1965 remodeling. Unfortunately, the building today bears no resemblance to the handsome structure shown in this view.

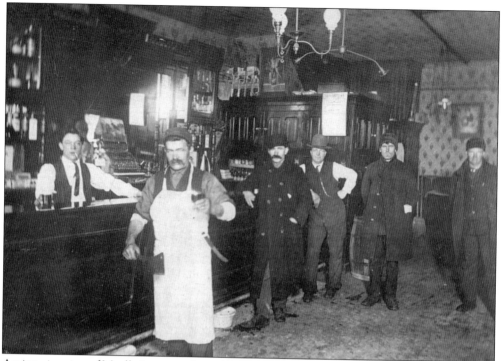

An interior view of Mueller's tavern about 1917 shows Louis Mueller Jr., tending bar for a number of interesting-looking customers, including one holding his beer in one hand and a butcher's cleaver in the other. Louis Jr. went on to serve in the Army in World War I and held other jobs during Prohibition. He ran the tavern following repeal of Prohibition in 1933 until the business closed for good in 1965.

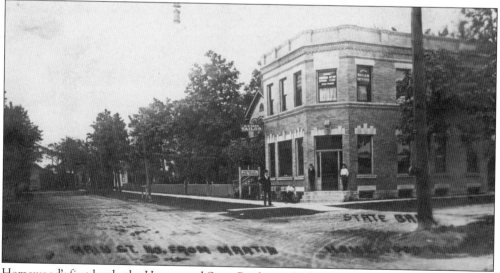

Homewood's first bank, the Homewood State Bank, was built in 1908 at the southeast corner of Main Street (Ridge Road) and Martin Avenue. Henry Gottschalk was president, James Cowing was cashier, and Henry Moecker and John Rabe were directors of the institution when first established. Over the years, changes to the building at 2025 Ridge Road have included a one-story addition to the front and the brickwork covered with Dry-Vit in the 1990s.

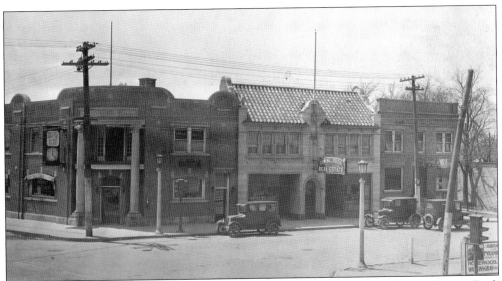

In 1924, construction started on Homewood's second bank, the Cook County Trust & Savings Bank (left), at the southwest corner of Ridge Road and Dixie Highway. The bank opened for business on January 10, 1925, with James Cowing serving as bank president. He built the center building in 1927 to house the real estate offices his sons Shirley and Frank operated. The Homewood Hotel (right) opened in 1912.

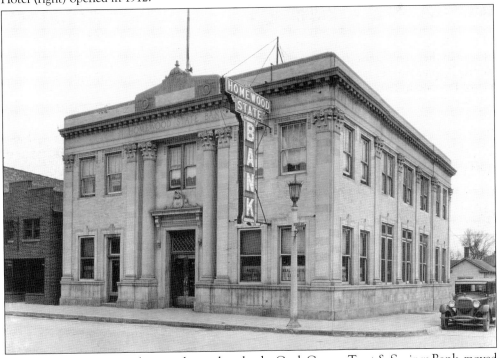

The Homewood State Bank, not to be outdone by the Cook County Trust & Savings Bank, moved into a new building on the northwest corner of Ridge Road and Martin Avenue in April 1925. The exterior of the handsome brick and limestone structure underwent significant remodeling in 1974 and now looks nothing like it did when built. Today, LaBanque Hotel and the LaVoute Restaurant occupy the building.

The grand opening on April 15, 1925, of the new Homewood State Bank was a gala affair, where hundreds of townspeople turned out to attend. The building also housed quarters for the Homewood Building and Loan Association. Troubled times were ahead for the bank, however, which closed in 1933, during the depths of the Depression and never reopened.

The grocery business was an important one in any town, particularly before the advent of "supermarkets." Henry Puhrmann (rear left) and Edward Lange (right) stand in the grocery they opened in 1914 on the south side of Main Street (Ridge Road), just east of Harwood Avenue. Puhrmann ran the business for about a decade and later was employed by the National Tea Store in Homewood.

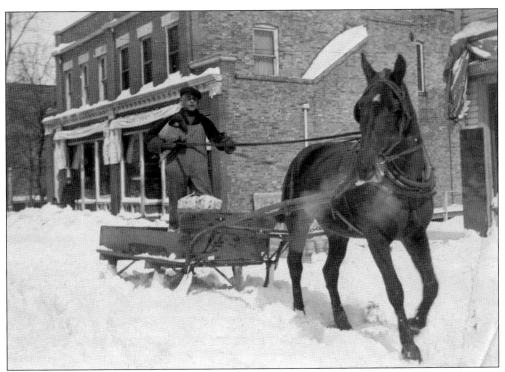

Grocers offered an added convenience to housewives in the early 20th century: home delivery. Horse-drawn wagons, later motor trucks, made these deliveries in town. Even in snowbound conditions, merchants relied on a horse and sled like this one driven by Arthur Frischkorn east on Main Street (Ridge Road). The property at 2048–2050 Ridge Road is seen in the background.

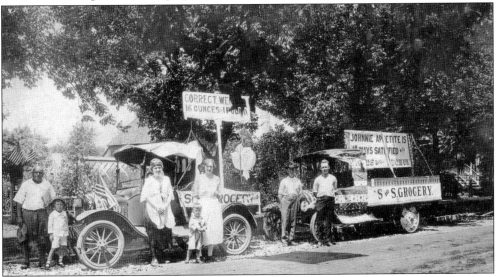

Leonard and William Schoof were other small business owners who ran a grocery in Homewood. They operated the S & S Grocery at 2135 W. 183rd Street during the 1920s. Here, from left to right, Herman Fiebig and his granddaughter, Elsie and Vernon Hecht, Lillian Schoof, Louis Schoof, and Leonard Schoof pose with S & S delivery trucks decorated to participate in a Fourth of July parade in the early 1920s.

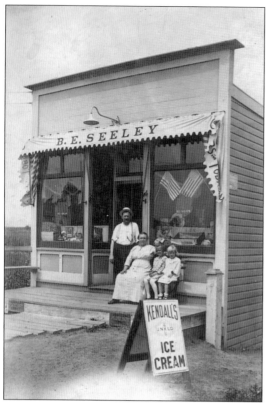

Bert and Louise Seeley relax in front of the grocery they ran on Main Street, later 1460 Ridge Road, on the east end of town. The couple operated the store for about 14 years during the 1920s and 1930s until Bert Seeley died in 1937. The view truly illustrates the nature of many mom-and-pop businesses so common during this period.

By the 1930s, franchise and company-owned grocers began to locate in Homewood. One of these was the Royal Blue grocery at 2057 Ridge Road. Edward (center with beard and cowboy hat) and Emma (to his right in image) Gitersonke owned the store for about 24 years. Their daughter Norma Jean (front) is also pictured. Gitersonke and employee Joe Hawblitzel (left) are dressed in western attire as part of Homewood's 1940 homecoming celebration.

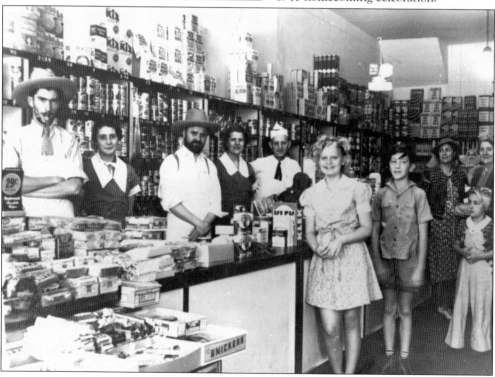

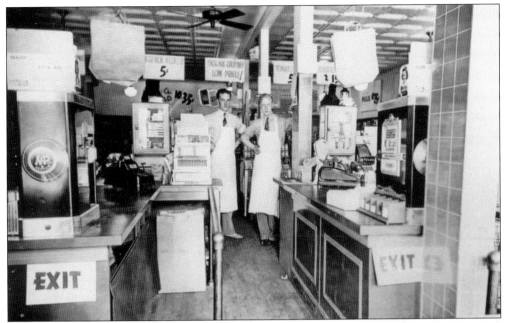

Another company-owned store that opened in Homewood was the Great Atlantic & Pacific (A&P) store. Edmund Besterfield was an early manager of the store, originally located at 2045 Ridge Road. As business grew, it moved to 1933 Ridge Road and later to a larger store on 183rd Street that has been enlarged further and is now Walt's Food Center. This view shows the evolution grocers were making to the self-serve and checkout counter concept.

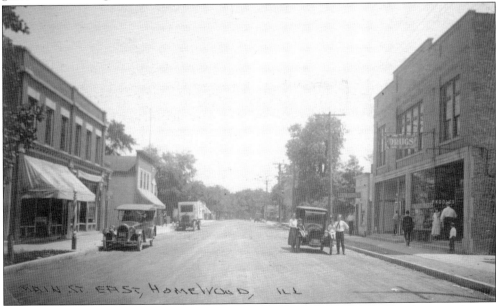

Druggist Jacob Sachs opened the Homewood Drug Company in 1911 in the storefront now known as 2051 Ridge Road. Sachs's store was the first in Homewood to have an electric sign hanging out front. Here, he and his wife, Esther, and their daughters Rose and Marion pose with the family car in front of the store in the 1920s. Sachs's store closed due to the effects of the Depression in 1935.

Homewood's second drugstore, the Community Pharmacy, was owned by Walter Muszynski and opened in 1925 in the Homewood Building on the northeast corner of Ridge Road and Dixie Highway. A drugstore would occupy this site for more than five decades. Business may have been slow on January 31, 1939, the day this photograph was taken, after 14 inches of snow fell on Homewood the day before. Travel Brokers is located here today.

Jacob Schwab, in apron, plays tug-of-war with townsfolk in front of his People's Store, which sold dry goods and clothing. The store, which opened in 1912, was located at what is now 2049 Ridge Road. Schwab's son Louis, who would go on to be an accomplished musician, is behind him providing added support. No doubt Schwab is trying to prove the durability of his clothing in this interesting view.

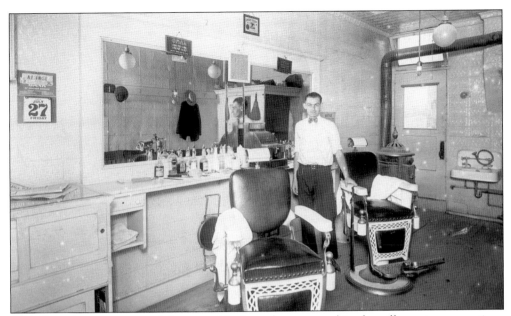

Fred Tatgenhorst was one of the several barbers that operated in the village at any one time. Originally opening his first shop in 1909 on Maria (183rd) Street, he moved "uptown" to a building he purchased on Main Street (2018 Ridge Road) in 1913. He continued to take care of the tonsorial needs of Homewood men until his untimely death at age 46 in 1931.

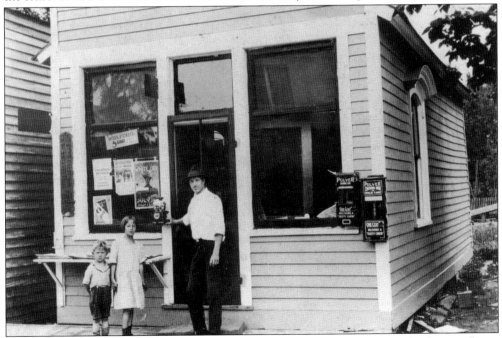

W. Sidney Steiner operated a news agency on the south side of Main Street (Ridge Road) just west of Dixie Highway during the first decades of the 20th century. Steiner sold school supplies, newspapers and magazines, many of which were published in German. He also sold a variety of candy to village children. This view from 1925 shows Steiner in front of his store with his son Sidney and daughter Agnes.

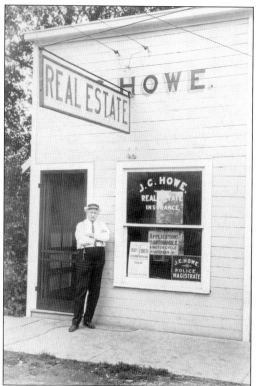

Jabez Howe Jr. was engaged in real estate sales in the village and had a small office on Main Street (Ridge Road) east of Funk's Hall. Later, he moved his office to the north side of Main Street. Howe was also an attorney and served as the village's police magistrate or justice of the peace from 1903 to 1931. To most residents, he was known simply as Judge Howe.

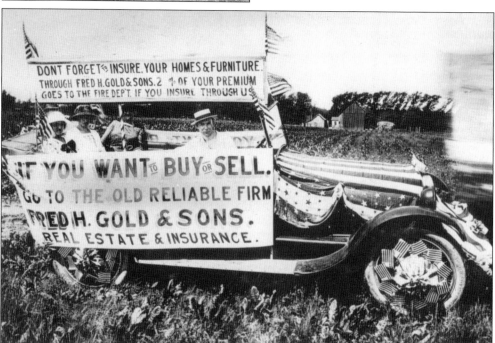

Fred H. Gold and his sons Alvin and Fred L. also sold real estate and insurance in Homewood. Fred H. was a very active man; he served terms as Homewood's fire chief, village trustee, and mayor and was involved in establishing the Homewood Building and Loan Association.

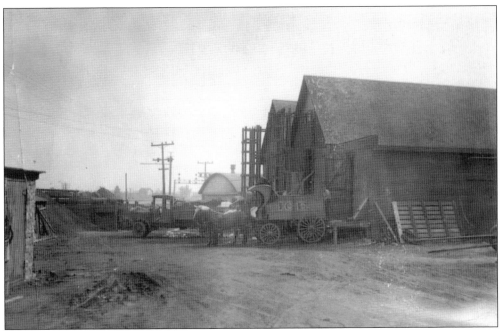

In 1920, Fred H. Gold and his sons established the Homewood Coal, Ice and Material Company on 183rd Street, just west of the Illinois Central rail tracks. Prior to the widespread use of refrigerators, ice was cut during the winter months from a large clay pond that was a leftover from the old brickyard operations. Large, insulated storage buildings held the ice until it was ready for delivery.

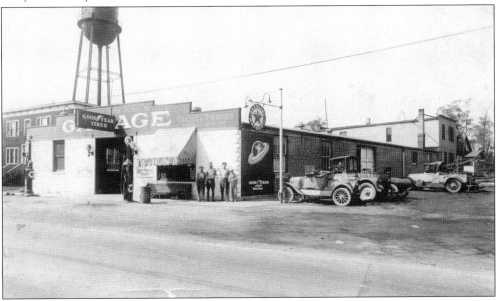

Andrew Severson built this modern auto repair garage in 1916 on Dixie Highway at Elm Road. Auto traffic increased through town with the establishment of the Dixie Highway in 1915, and there was plenty of business repairing and servicing the autos of touring motorists. Severson later sold the business to his son-in-law Ted Utermark Sr. The building remained until 1966, when it was burned down to clear land for the current fire station.

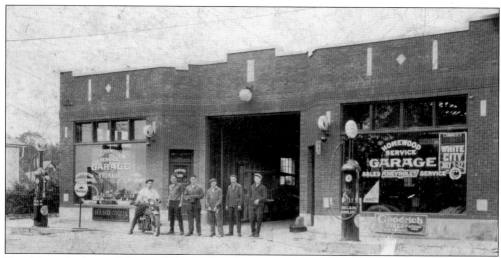

Bert Heuer Sr. (second from right) completed construction of the Homewood Service Garage in 1924 on the west side of Dixie Highway just south of Ridge Road. Heuer not only repaired cars and sold Sinclair brand gasoline here, he also sold new Chevrolets. Business was good until the advent of the Depression, which caused the garage to close. The building was remodeled to house the Homewood Theatre in 1937.

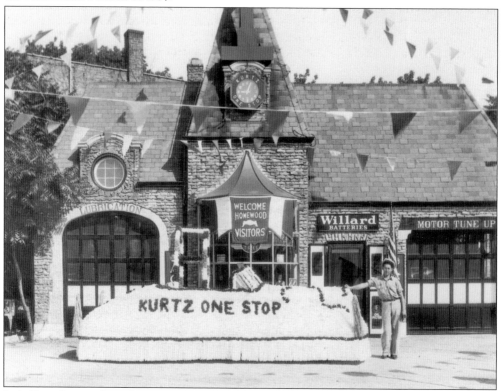

Jack Kurtz Jr. stands in front of the quaint, cottage-style service station that was built on the northwest corner of Ridge Road and Dixie Highway in 1933. Kurtz sold Sinclair brand products at the station for the next five decades. A newer building was built in the late 1950s. Though extensively remodeled over the years, it still serves as a convenience store for the gas station.

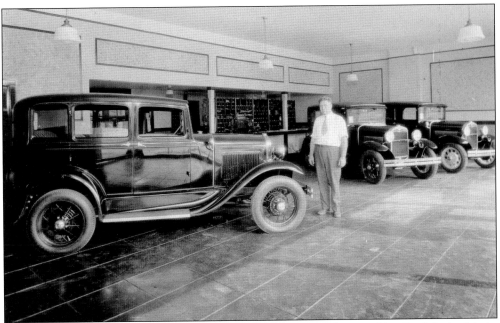

Just a year into the Depression, Morse J. Van Drunen (pictured) started his Ford dealership in September 1930. Homewood's oldest business, Van Drunen Ford was originally located at 18029 Dixie Highway. The company operated here for about 20 years, then moved to 183rd Street and Dixie Highway for about 23 years. It has been at its current location, 3233 W. 183rd Street, since 1973.

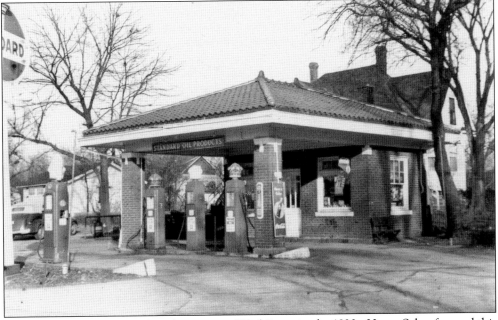

The Schoof family had a lock on business on 183rd Street in the 1930s. Henry Schoof owned this Standard brand gasoline station located on the northeast corner of 183rd Street and Harwood Avenue. The Craftsman-style filling station was later replaced by a more modern structure in the 1950s, and a BP gas station and convenience store occupy the site today.

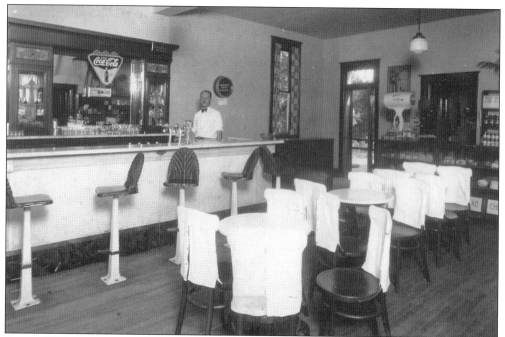

Leonard Schoof stands behind the soda fountain in the confectionery he operated at 2117 W. 183rd Street from the late 1920s until 1933. The store sold candy and ice cream, had a lunch counter, and sold a small selection of grocery items. After Prohibition ended in 1933, Schoof opened a tavern at 2131 W. 183rd Street.

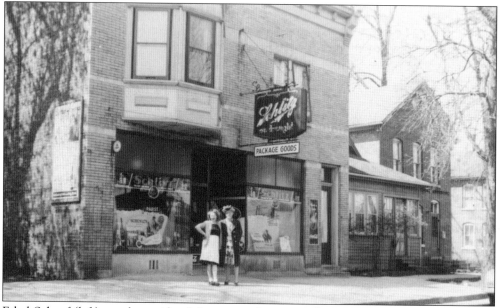

Ethel Schoof (left) stands outside of the tavern she operated at 2131 W. 183rd Street after her husband, Leonard, died in 1941. The building was later sold to William Lassen, who opened Lassen's Tap. Lassen embarked on plans to enlarge the structure in 1969, and the construction activity caused the walls to begin to crack and collapse. It was demolished, and the current building was completed in 1970.

George Alexander opened Alexander's Sweet Shop, a candy store, luncheonette, and soda fountain in October 1929 at 1961 Ridge Road. He opened a liquor store next door at 1959 Ridge Road in 1941. He sold the sweet shop to Thomas Kataras in 1947. The Kataras family operated at this location for 20 years until they built a new restaurant at 1944 Ridge Road. The restaurant closed in 2012 after 65 years in business.

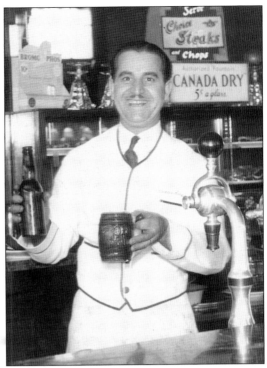

Brothers Steve and John Surma look over a menu in the kitchen of their restaurant they opened at 175th Street and Dixie Highway in 1946. A fire destroyed the original building in 1959, and the family rebuilt. A popular spot for classic American fare, Surma's remained in business until 2003, a total of 57 years. Balagio's Restaurant occupies the site today.

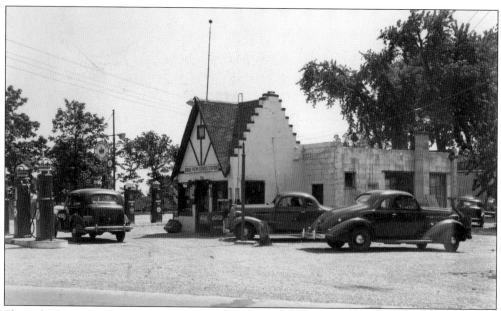

Ely and Christine Chulibrk owned this cottage-style service station at the southwest corner of Ridge Road and Halsted Street in the 1930s and 1940s. The business was sold to Al Van Es in 1945, and an explosion destroyed the building in 1949. The Speedway gas station and convenience store are located on the site today. The Chulibrk family also owned Ely's trailer park, located just west of the station.

Christine Chulibrk (right) stands behind the lunch counter in the diner she operated on the northeast corner of Ridge Road and Halsted Streets in the 1930s. Prices were much cheaper then; the menu board advertises hamburgers at 10¢ and a barbecue beef sandwich for 15¢. The business later became the Shot Put Inn, owned by Donald McEachern. The site is currently occupied by a Shell gas station.

Neutrowound Radio Manufacturing Company moved its production facilities from Chicago in 1925 to a new plant built south of the Homewood Coal, Ice & Material Company on 183rd Street, just west of the Illinois Central tracks. The company closed the Homewood plant and moved out-of-state in 1928. The building was later taken over by the Parsons Ammonia Company and was leveled in a spectacular fire on July 3, 1967. Flosswood Condominiums occupy a part of the site today.

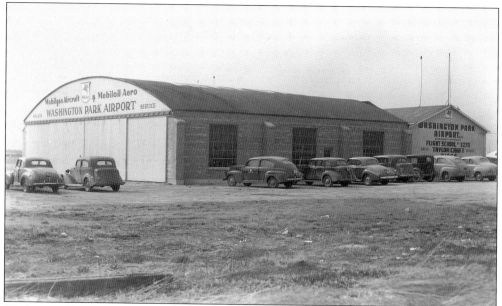

Washington Park Airport, established in 1939, was located on the west side of Halsted Street south of 187th Street. Before the war, the airport offered flying lessons to novices and hanger storage facilities for airplane owners. It also provided shuttle services to and from Washington Park Race Track for the many horse race fans that flew in and out of the airfield.

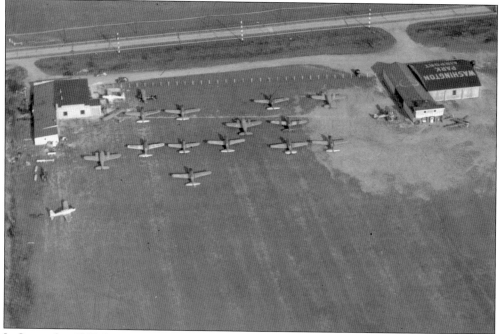

In September 1942 the airport entered into a contract with the US Army to provide flight training to air cadets. These cadets trained for non-combat duty in the ferry and transport commands and as glider pilots. After the war, the "port" again offered general civil aviation services, but its future was short-lived. Fires in August 1947 and February 1950 destroyed the airport's hangars and office building, causing it to end operations.

By 1950, Homewood's business district was still relatively compact and there was plenty of room for development in town, as this aerial photograph from the time illustrates. The view looks east with Ridge Road at left and 183rd Street visible in the upper right portion of the photograph. The 1950s would be a decade of tremendous growth in the village, with a great deal of open land becoming residential subdivisions.

DISCOVER THOUSANDS OF LOCAL HISTORY BOOKS FEATURING MILLIONS OF VINTAGE IMAGES

Arcadia Publishing, the leading local history publisher in the United States, is committed to making history accessible and meaningful through publishing books that celebrate and preserve the heritage of America's people and places.

Find more books like this at
www.arcadiapublishing.com

Search for your hometown history, your old stomping grounds, and even your favorite sports team.

Consistent with our mission to preserve history on a local level, this book was printed in South Carolina on American-made paper and manufactured entirely in the United States. Products carrying the accredited Forest Stewardship Council (FSC) label are printed on 100 percent FSC-certified paper.

MADE IN THE
USA